Life Drawing Class

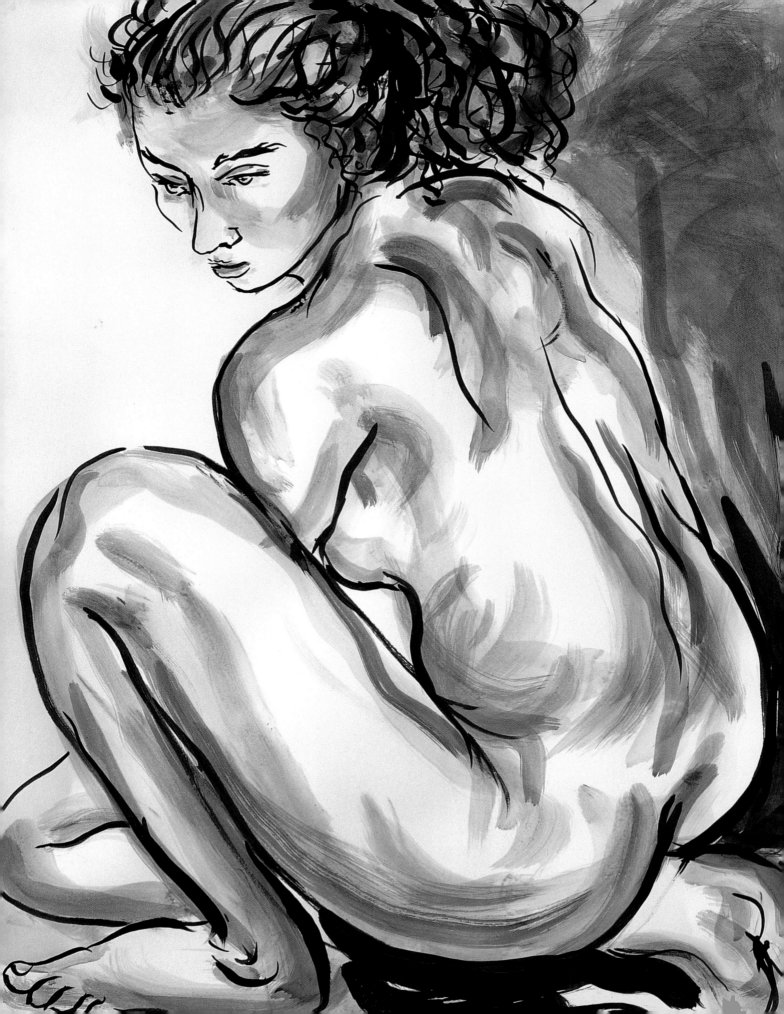

Life Drawing Class

LUCY WATSON

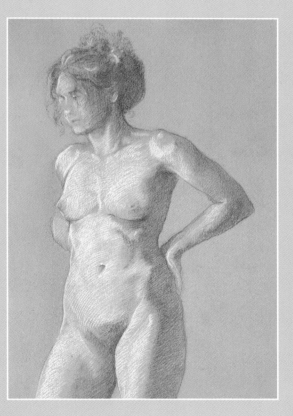

WATSON-GUPTILL PUBLICATIONS/NEW YORK

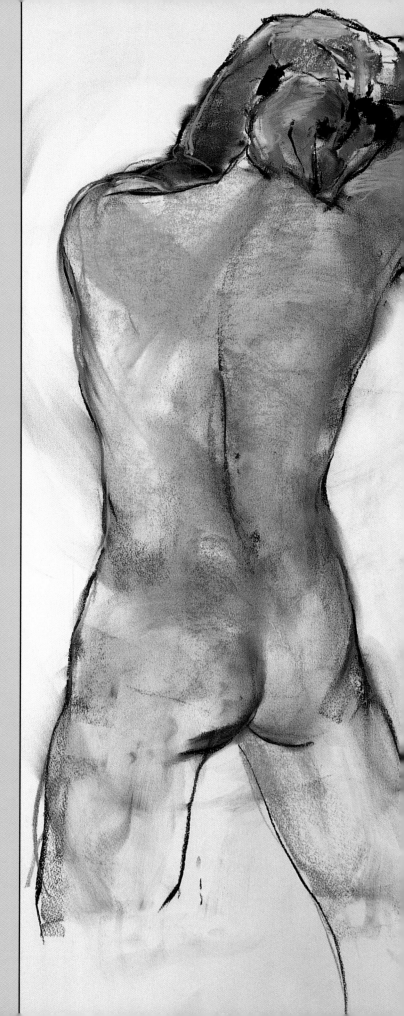

A QUARTO BOOK

Copyright © 2003 Quarto Inc.

First published in 2003 in New York by
Watson-Guptill Publications, a division of
VNU Business Media, Inc., 770 Broadway,
New York, NY 10003.

ISBN 0-8230-2767-8

Library of Congress Catalog Card Number is available on request.

Project editor Vicky Weber
Art editor Karla Jennings
Assistant art director Penny Cobb
Designers Rebecca Painter and Karin Skänberg
Photography Colin Bowling
Text editors Gillian Kemp
Proofreader Deirdre Clark
Indexer Diana Le Core

Art director Moira Clinch
Publisher Piers Spence

Manufactured by ProVision Pte Ltd, Singapore
Printed by Star Standard, Singapore

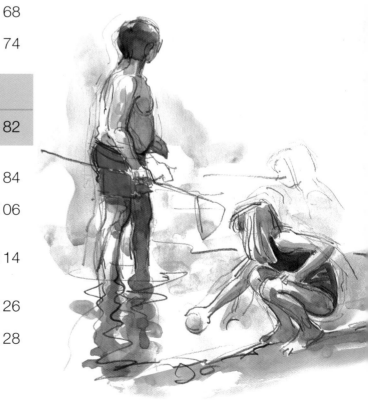

Introduction

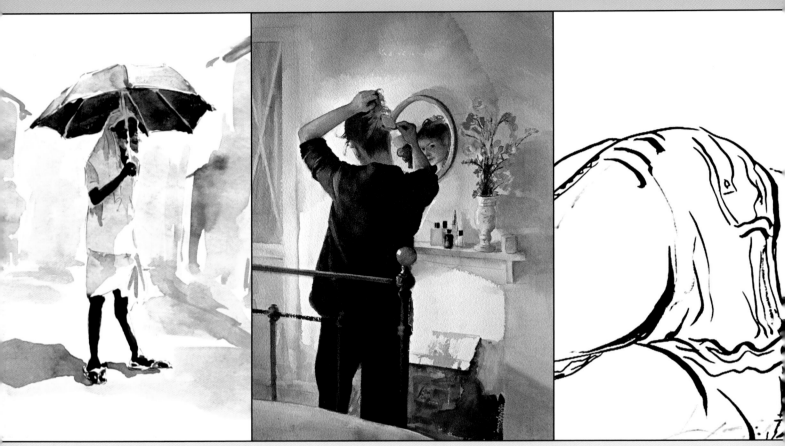

The figure is often the first subject we draw as children but not many of us can, as adults, draw a figure with the same cheerful lack of inhibition. As we become older, our concerns are with achieving technical correctness in terms of anatomy, proportion, and foreshortening. In figure drawing, lack of correctness is immediately obvious—and if we deliberately exaggerate or distort the figure for artistic effect, as Picasso or Modigliani were able to do so brilliantly, it risks looking hopelessly inept. It is, thus, easy to appreciate why drawing a figure is approached with a degree of trepidation. Mastering the techniques required to draw the figure well takes patience and perseverance. But, for the student who takes up the challenge, once the fundamentals have been learned, the figure as a subject will provide an endless source of inspiration.

This book sets out to explain the key aspects of figure drawing in a series of step-by-step classes that cover structure, dynamics, light and tone, color, and compositional techniques, working with a broad range of drawing media. Each class is

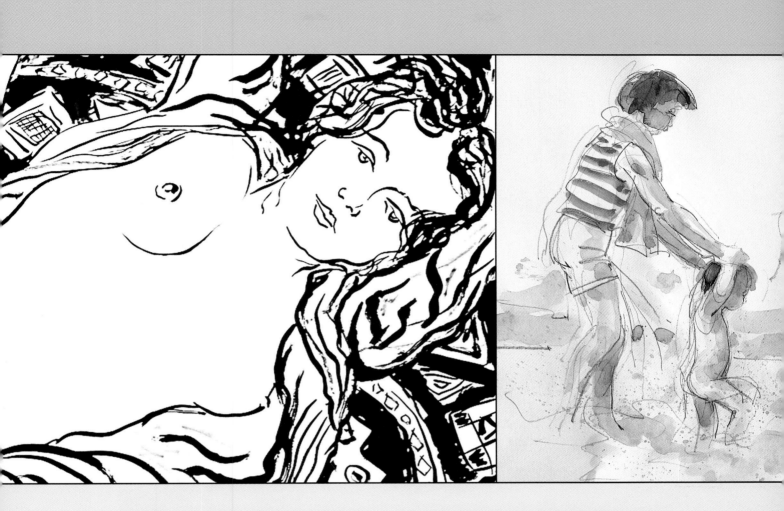

assigned to an experienced artist chosen for his or her specific area of expertise. The reader will learn some invaluable practical tips on how to tackle the figure first hand, as well as how each artist has approached the subject and interpreted it in a unique style. There is a "Learn from the Pro" gallery after many of the classes that illustrates how professional artists have chosen to represent a specific aspect of figure drawing. Finally, the step-by-step projects in the third section of the book put the figure in context and look at how surroundings can influence a picture.

The different components of *Life Drawing Class* demonstrate a range of interpretations of how the figure has always been, and still remains, a stimulating source of inspiration— it is a fascinating subject and I hope you will find it both enlightening and enjoyable.

Lucy Watson

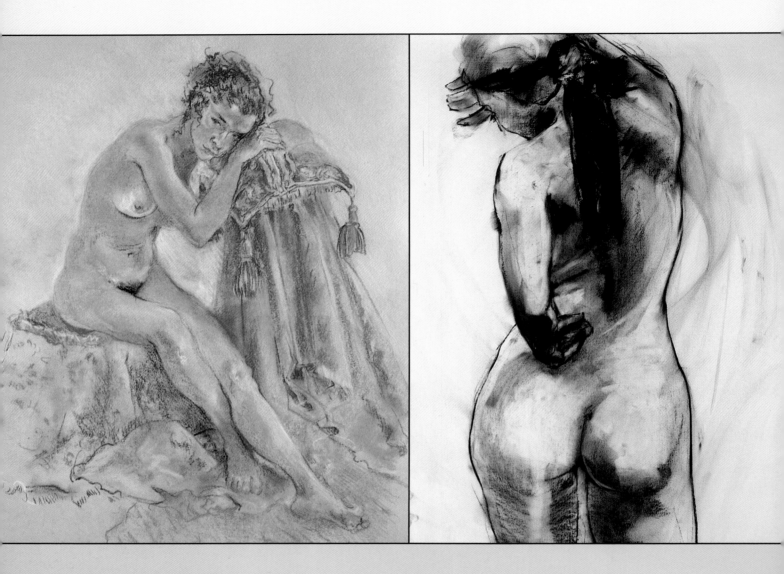

1 Drawing figures

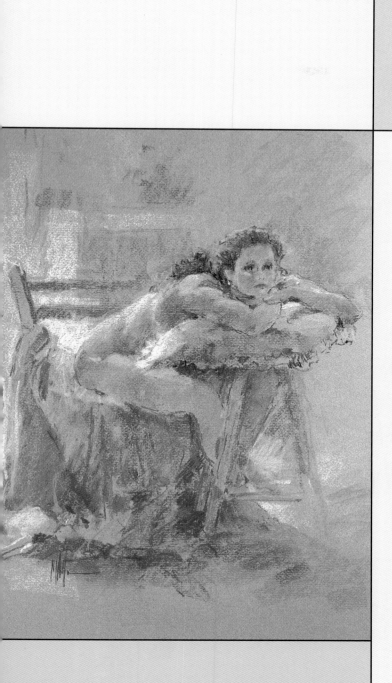

When you start drawing figures, pretend you have never seen one before. Think of the model as a mechanical construction, a collection of different parts, held together by a framework which always conforms to a set of basic proportions and is capable of movement.

the body

theory

There is a basic uniformity to the human skeletal and muscular structure—the "scaffolding" beneath the skin.

Observe your own body to gain an understanding of balance, movement, and weight distribution. Try this simple exercise: Set up a full-length mirror, gently flex your limbs, and watch how the body moves and rotates. No movement should be difficult or forced, just look at the natural movement and limitations of the joints and muscles. Roll your head gently and notice its weight—you may be surprised. Lift your hands and lay them on each side of your neck. See the powerful muscles stretching as you move your head; and feel the dynamics at work. Now lift and drop your shoulders to bring the collarbone into view; notice the dark hollows that form. Lift your arm, bending the elbow and wrist: The muscle at the shoulder and bone at the elbow and wrist protrude. Move down the body, gently flexing the different parts. When you have finished, relax, resting your weight on one leg, and observe how this leg aligns with the head.

Perform the exercise again in morning light, evening light, sunlight, artificial light; see how different the body and its features appear. Or try it in a variety of clothing: Loose shirts will echo some of the muscular tension by pulling taut across the shoulder blades and at the elbows, while a woolly sweater will disguise the anatomy. Although we may feel we know our bodies well, scrutinizing it objectively in this way will prove an anatomy lesson in itself.

Body structure

The skeleton is a foundational support that forms the shape of the body. The female skeleton is usually smaller at the shoulders and wider at the pelvis. This "scaffolding" is clothed with a complex pattern of muscles and tendons, some of which are noticeable as they flex.

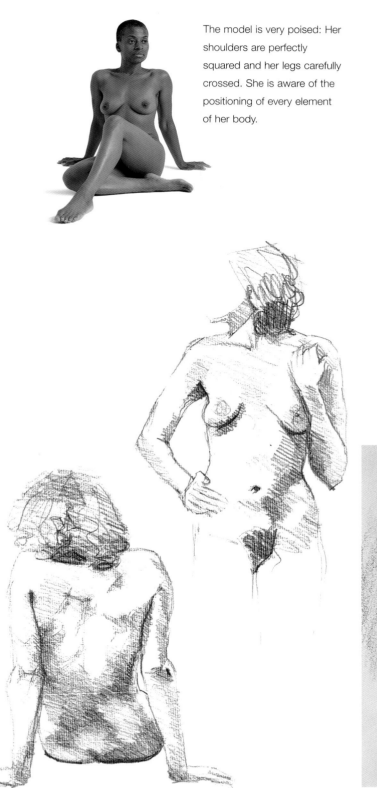

The model is very poised: Her shoulders are perfectly squared and her legs carefully crossed. She is aware of the positioning of every element of her body.

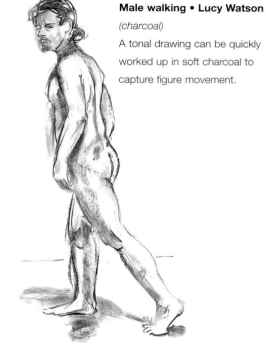

Male walking • Lucy Watson *(charcoal)*
A tonal drawing can be quickly worked up in soft charcoal to capture figure movement.

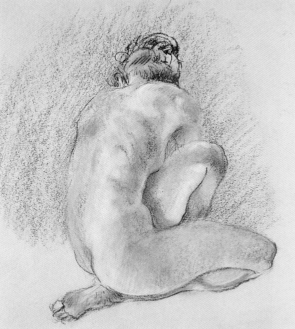

2 studies • Isabel Hutchison *(graphite pencil)*
Soft directional lighting accentuates the muscular structure. It is described here with hatching using pressure on the graphite pencil to create shading.

Back view of female • Lorna Marsh *(chalk pastel)*
The female muscular structure is less pronounced than that of the male, and is often smoother and more rounded.

balance and proportion

theory

Establishing the balance of the figure at the beginning of the work will help convey a sense of naturalism.

We have an innate sense of balance that constantly steadies us as we go about our daily lives. Many of our movement shifts are so instinctive that we only become aware of them when we analyze and draw the figure. Get a feeling for the balance of a pose by first sketching a "stick" person—simple lines running centrally down the limbs and body, which can then be fleshed out later.

USING A VERTICAL LINE TO MEASURE BALANCE
A ruler will come in useful as it provides a long straight edge.

Hold up the ruler against your model roughly bisecting the head. Look down the straight edge and you will notice the areas of the body that line up along it. This provides a useful guide to balancing the figure.

The vertical line can be moved to measure other parts of the body, particularly to gauge distances between various significant points.

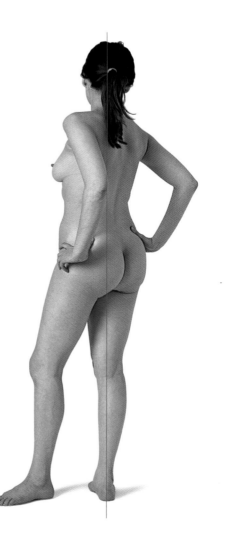

The leg bearing the upper body weight automatically aligns with the head. Use a straight edge, such as a ruler, to check balance and weight distribution in the pose.

MEASURING PROPORTION WITH THE PENCIL

Stretch your arm out, holding your pencil vertically in front of you. Close one eye and line up the pencil so the top is level with the top of the head.

Now, holding the pencil still, move your thumb down the pencil to the point that aligns with the chin. The length from your thumb to the top of the pencil is the head length. Note this length and use this as your yardstick as you measure the rest of the figure. Move the pencil down so that the tip lies at the chin. Make a mental note of the point on the body where your thumb now lies: It will probably be in the area of the chest.

Repeat this measuring process until you come to the feet. In an adult body, the head length should fit approximately seven to eight times into the height of the standing figure and three times into the height of the squatting figure. A child's head fits into the body fewer times because the head is proportionately larger. The head of a newborn baby fits about four times into its body.

When you have established the proportions, you can then draw them onto a grid and scale them up or down to fit on your piece of paper as you desire.

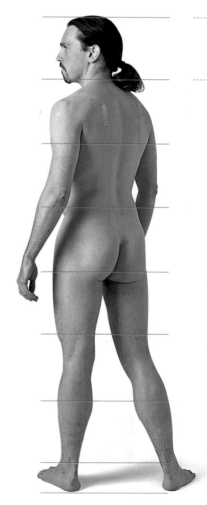

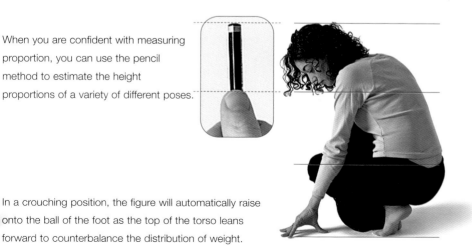

Standing male • Isabel Hutchison *(graphite pencil)*
The figure looks evenly balanced: A vertical line could be drawn from the back of the head, down the spine, and along the inside of the straight leg.

When you are confident with measuring proportion, you can use the pencil method to estimate the height proportions of a variety of different poses.

In a crouching position, the figure will automatically raise onto the ball of the foot as the top of the torso leans forward to counterbalance the distribution of weight.

MEASURING ANGLES WITH THE PENCIL

A pencil is a useful measuring tool to ensure you correctly represent the positioning and angles of limbs on a 2-dimensional surface.

Again holding the pencil in front of you and closing one eye, align it along the arms and legs, this could follow either the edges or the middle of the limbs, whichever is the easier. When you have done this, focus on the pencil and estimate the angle. Use this angle as a marker as you draw the limbs on the paper.

The simple crouching profile encourages the eye to concentrate on the angles made by the head, torso, and limbs in relationship to one another.

Crouching male • Lucy Watson

(color pencil)

By aligning the pencil against the pose, a steep continuous slope can be seen to run from the nape of the neck down the figure's back. By then aligning the pencil with the center of the right thigh, an approximate 90 degree angle was achieved to form the "L" shape that characterizes this pose.

Take a measurement with the pencil, roughly running through the center of the upper arm, then the lower arm, and lastly out through the hand.

The pencil was lined up with the front edge of the left leg to show its angle of slope and this line bisects the right thigh at the approximate halfway mark.

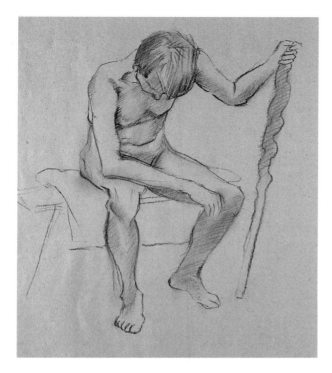

PLOTTING POSITION WITH PENCIL AND NEGATIVE SPACES

A pencil can be used to link key points on the figure to ensure you have placed them accurately. For example, by aligning the pencil to pass through both kneecaps you can check they lie the right distance apart and at a realistic angle to one another. Continue to make comparisons, by linking the shoulders, the elbows, large toes, or whatever pairs are visible on the figure. Looking carefully at the spaces between the limbs is a great way of verifying their positioning. Checking these "negative" shapes is often easier than checking the limbs as they present a larger, more defined area, particularly if your model is set against a dark background.

Man sitting with staff • Isabel Hutchison (graphite pencil)
The right hand and knees all lie on the same plane, a steep angle rises from the right to the left hand holding the staff, while an approximate 40 degree angle lies between the two large toes.

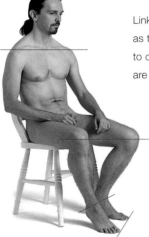

Link key points together such as the toes, knees, and shoulders, to check spacing and angles are correct.

Seated nude • Isabel Hutchison
(graphite pencil)
Looking at the shapes created in the negative spaces will help you position the limbs correctly.

balance and proportion

Length of pose	30 minutes

media
4B graphite pencil
Ruler or straight edge
Drawing paper

This standing pose rests the upper weight of the body on the right leg. It is crucial to establish the weight distribution at the very beginning or the figure could easily appear to topple over when drawn. To find the key line of balance, hold a straight edge up in front of the pose so that it bisects the head at the center. You can then see what other elements of the pose line up against this vertical line. It is also important to check the proportions of the figure using the pencil method, explained on pages 12–15, before you start. Even from this rough approximation, you can decide whether to make the figure larger for the size of your paper or smaller to fit it all in.

You might be surprised to discover that the head aligns with the leg holding the weight. Try the pose in a mirror and shift your weight from one leg to the other and you will see how the head lines up with the weight-bearing one. If your model's hair obscures the actual base of the head (as here), you will need to envisage where this point would lie. Sketch in an oval to represent the head to make the measurements to and then add the hair at a later stage.

drawing figures

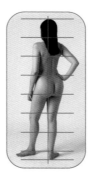

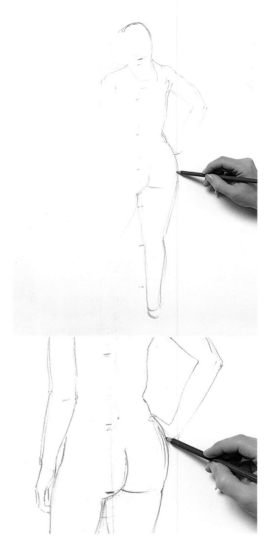

Step 1 Draw an oval shape to represent the head near the top center of your page. Using a ruler, lightly draw a straight vertical line through the middle of it down to the bottom of the page. Now hold up a straight edge against the posed figure, bisecting the head through the center as you did on your drawing. You will see that the head aligns with the inside of the right leg, demonstrating how the weight of the upper body is distributed. Now measure the proportions of the figure from the head down through the straightest leg (on the right), using the pencil method. You will normally find the head fits seven to eight times into the height of the figure.

The oval you drew is representative of the head size, so take its length and measure it down the line approximately 7½ times. The last measurement will indicate where the right heel will be placed. Make a small mark here so you can judge how large your drawing of the figure will appear on your paper. If the height of your figure is too large or too small for the page, adjust the head size and count down the figure again 7½ times. When you are happy with the proportion of your figure you're ready to draw the contour.

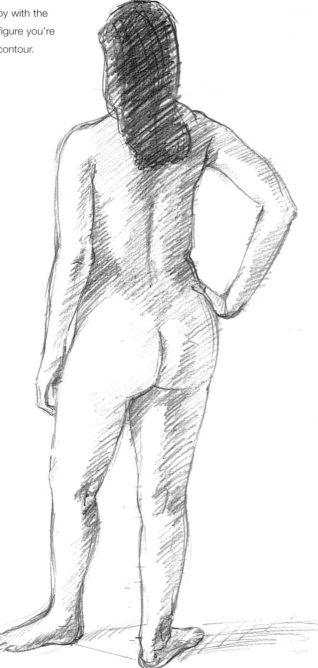

Step 2 After all the measuring in establishing the balance and proportion of the figure in stage one, the contour can now be freely drawn in. However, keep analyzing the pose against the drawing at every stage.

Step 3 Add some hatching to give the impression of 3-dimensional form. Note that the light is coming in from the left, casting the right side of the body in shadow. Softly work a first layer of hatching over the body to form a mid-tone. Go over again, using more pressure, to build up the tone in the darkest shadows. Finally the hair is loosely hatched in to form the darkest area of tone.

TECHNIQUES

hatching, see page 114

cross hatching, see page 114

sketching with a pencil, see page 114

perspective

theory

Using perspective and foreshortening you can achieve a realistic 3-dimensional effect on flat paper.

Perspective in its basic form means that the further things are away from you the smaller they appear. Sometimes it is helpful to think of this the other way around: The nearer things are to you the larger they appear. A keen sense of observation and trust in what you see will help when dealing with the figure subject. Use the pencil method of measuring (see pages 12-15) to get the angles and the proportions of the limbs right.

Foreshortening is an all-important technique to learn in order to achieve realistic perspective in figure drawing. It involves the distortion or apparent shortening of certain figural elements in the composition to create the illusion that they are closer to the viewer's eye.

This wooden mannequin (widely available in art stores) shows how the head and limbs can be broken down into simple cylindrical shapes.

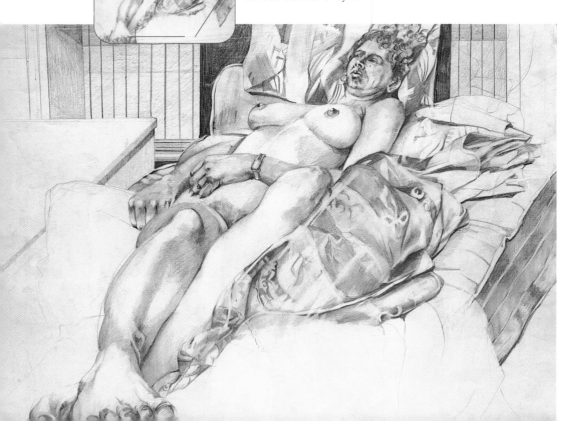

Woman reclining on mattress • Lucy Watson
(graphite pencil)
Compare the size of the foot with the head in this foreshortened pose. By measuring the head with the pencil and then measuring the foot, the artist could establish how much larger the foot appeared in relation to the head.

The limbs and extremities often present several foreshortened viewpoints in the figure at any one time. It is easy to understand this if you reduce the figure to very basic shapes. You may be tempted to begin working on the details of the figure immediately to make it look lifelike, but it is vital to get the underlying structure and positioning of the pose down first.

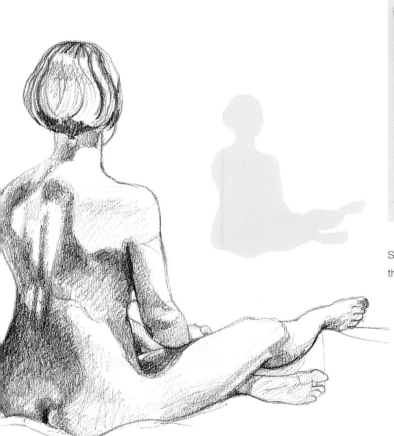

Seeing the body and limbs as simple shapes will help you describe their scale and form when seen at a foreshortened angle.

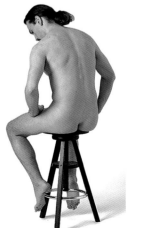

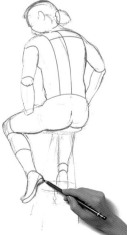

Seated female • Isabel Hutchison (graphite pencil)
Look at the silhouette—it doesn't look at all like a leg, but presents a rather unusual truncated shape. It is only when light and tone are added that it makes sense as a leg.

foreshortening

Length of pose	1 hour

media
2b graphite pencil
White drawing paper

A natural composition with the figure is likely to present at least three or four foreshortened aspects. This exercise shows you how to put into practice foreshortening techniques: Measuring proportion and aligning angles with the pencil, reducing the figure to basic shapes, and looking at negative space to tackle a dramatically foreshortened pose.

Before putting pencil to paper, carefully analyze the pose. Looking down onto this reclining pose from above, some of the features are obscured—the upper part of the left arm, the stomach, and most of the face. Measure with the pencil to check proportions and angles (see pages 12–15).

Align your pencil along each of the limbs in turn to familiarize yourself with the angles they take in relation to one another. The effect of perspective has made the visible lower half of the left arm appear longer than the left thigh.

Step 1 Lightly sketch in the contour and focus on the shapes the head, torso, and limbs make. The arms form a large Z, bisected in the middle by the mass of hair. Lightly draw them in, bearing this in mind. The face is only partially visible, so use the eyebrow line as a guide to placing the other features. The left nipple is positioned just above the forehead—unlikely as this might sound. This will provide a reference point to position the right breast on a horizontal line. The right thigh presents a tall cylinder while the other thigh appears as a truncated cone shape. The sole of the left foot rests at a right angle to the right thigh, forming a square, negative shape on the drapes.

Step 2 Recheck the angles of the limbs by aligning with your pencil and look at the negative spaces to check your positioning. Then begin to work up areas of tone to describe the 3-dimensional volume of the body. Use the trick of squinting to define the darkest areas of tone and add areas of light hatching to these. Follow the form of the torso around to suggest its flattened cylindrical form and add some light cross hatching on the outer side of the right thigh and on the shadowed calf behind and on the upper left arm. Add the details of the fingers in the cupped left hand. Strengthen the facial features and describe the mass of curly hair in tendrils.

TECHNIQUES

hatching, see page 114

cross hatching, see page 114

sketching with a pencil, see page 114

Step 3 Sketch in the undulating folds of the sheet and add the gentle shadows with light hatching. Add a few final touches of definition to strengthen the figure on the background and ensure it does not appear to float in space.

dynamics

theory

Body dynamics are the many and various "stresses" of which the human body is capable.

In figure drawing, dynamic representation is usually confined to gentle twists and stretches of the body to capture curves and undulations of muscle. Working from photographs can sometimes stifle the sense of spontaneity that is the essence of life drawing, but they are a useful reference—particularly with more ambitious contortions—and enable you to analyze the "dynamics" of action. As photographs only capture a moment in time, vitality and dynamism have to be conveyed through your drawing methods. Working with short poses encourages this and many life classes start with 15-minute, warm-up poses—you might be surprised how well the drawing can capture the living quality of the figure without measuring angles and proportions. Knowing that time is limited keeps the drawing moving, as you focus on essentials rather than details.

You will perfect your technique with experience; but before you reach for the eraser, remember that the Renaissance masters saw "wrong" marks—which they called pentimento or "repentance"—as contributing to the work and giving it that crucial sense of liveliness. An uninhibited approach will help your work infinitely more than trying too hard to get it right first time.

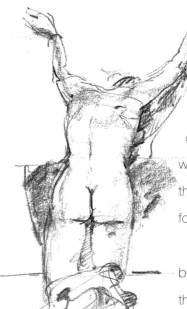

Woman kneeling • Lucy Watson *(charcoal)*
If the model only holds position for 5–10 minutes, you can afford to choose more dynamic poses.

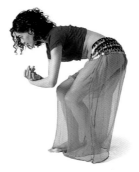

Capture movements in photographs.

Bald man stooping • Lucy Watson
(charcoal)
A brisk sketch is made, "modeling" the figure in tone by smudging the charcoal with the finger to create a strong sculptural effect in the description of form.

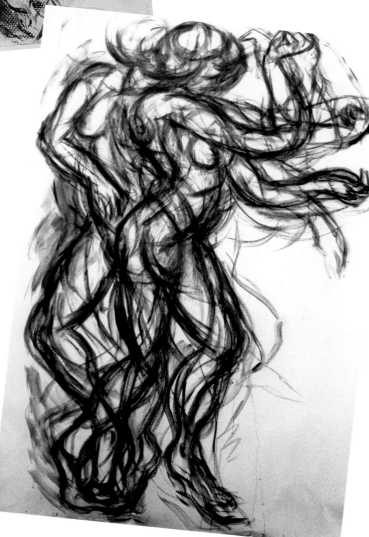

**Woman with arms raised behind head •
Isabel Hutchison** *(graphite pencil)*
Lightly hatching the upper part of the body expresses all the grace of this relaxed pose.

Dancer • David Cottingham
(conte chalk and acrylic wash)
The vigorous brushwork echoes the vibrant activity of the figure, bringing the work to life.

objectives • Using line drawing to compose a fluid sequence of movement around a fixed point • Working one pose into another on one sheet of paper

movement

Length of pose	4 10-minute poses

media
4B graphite pencil
Drawing paper

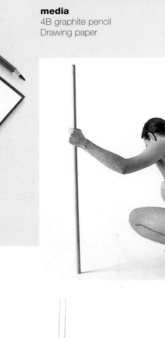

The aim of this class is to record a sequence of movements on one sheet of paper. The model sets the pace by moving through four movements, rising from a squatting position, to a standing then walking position, holding each pose for about 10 minutes. The model holds a staff, helping to support the second and most demanding pose, which sees him rising from the floor to stand. The pole is kept static, heightening the sense of movement of the figure as he revolves around this fixed point. This also encourages the artist to overlap the drawings, working each one into the next.

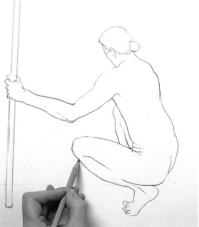

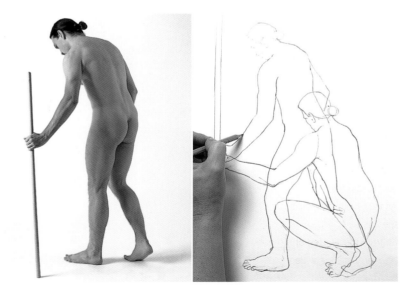

Step 1 The first position is taken up, squatting on the floor, grasping the pole to keep balance. Sketch the contour of the figure. Pay attention to the underside of the left thigh as it slopes over the calf, almost obscuring it by the time it reaches the ankle. By following this line down you will really imbue the drawing with a sense of weight as the buttock rests on the heel.

Step 2 The figure rises into the second pose taking a step forward to maintain his balance while keeping his hand fixed in position on the pole. As the figure has not moved forward very much, draw this pose almost entirely "into" the first. Using a fine linear line will prevent the second drawing from obscuring the first and so present a good link between the two drawings.

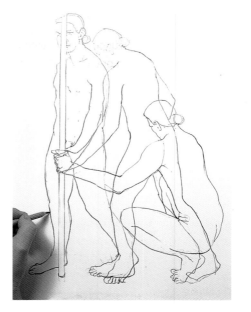

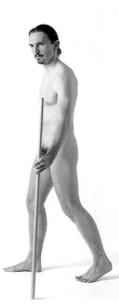

Step 3 The model takes a step forward and holds the new pose for a further 10 minutes. The vertical pole proves a useful guide on which to measure the balance of this walking position. The pole bisects the right foot at the heel and travels just right of center through the leg, and lastly upward through the chest.

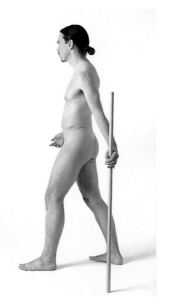

Step 4 The pole still acts as a useful measure for this position. As the left leg moves forward, the right foot appears to move up from the bottom of the pole, creating a sense of depth in the drawing.

TECHNIQUES

sketching with a pencil, see page 114

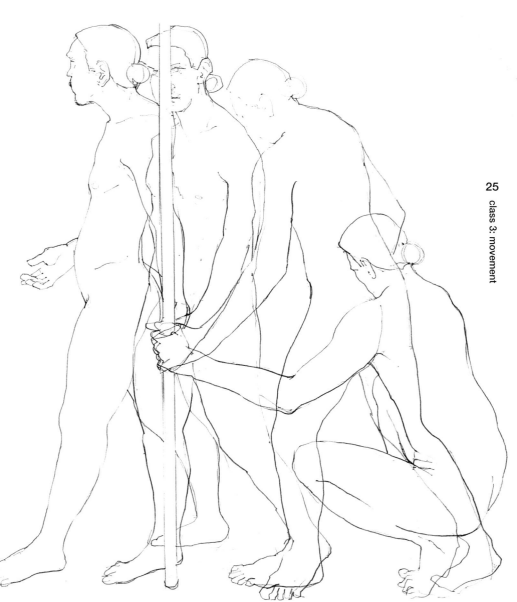

class 4

objectives • Training your eye to observe and translate • Loosening up your drawing method • Losing inhibitions and having some fun!

short poses

Length of pose	5-20 minutes

media
White cartridge paper
2b graphite pencil
Sanguine pastel
Charcoal

Before embarking on a long sitting, it is good practice to do some five-minute poses and then a twenty-minute session. Working quickly and concentrating on essentials infuses the figure with a "living" energy.

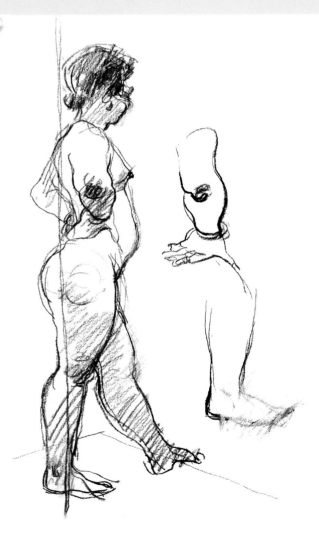

Five-minute poses provide a good warm-up exercise, helping you to loosen up, a little like a dancer before a performance. In addition to the physical warm-up, they also help to focus and familiarize the eye to the structure of the figure as a whole. At this stage the intricate details of hands, feet, and facial features can be ignored, concentrate instead on the form and balance of the figure, capturing perhaps the angle of the limbs or a fleeting sense of movement.

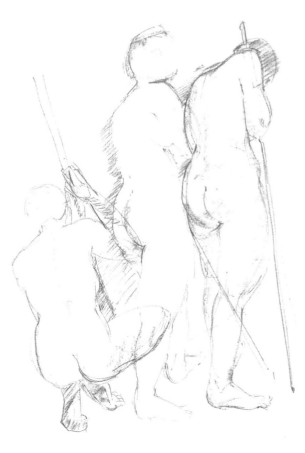

Supporting her weight with the staff, the figure moved through a series of three movements holding each pose for 10 minutes. Working the figures into one another enhances the sense of sequential movement.

TECHNIQUES
sketching, see pages 114 and 118
hatchng, see page 114
blending, see pages 116 and 119

The models held, then dropped these poses randomly at
five-minute intervals, after which they took up a pose for
10 minutes. This was later to be the position of the longer pose,
which lasted for 90 minutes.

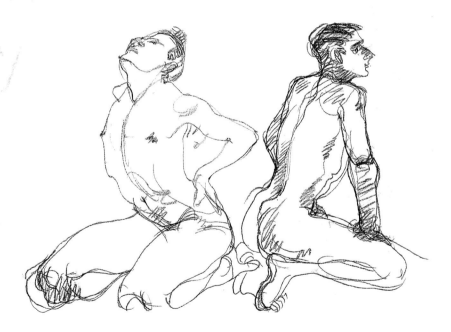

A longer pose—for 20 minutes or half an hour—as a forerunner
to a full sitting enables you to make a number of informed
decisions. You might decide to sharpen the lighting, reposition
the hands and feet, or alter the tilt and direction of the head.
These adjustments are best made after completing a 20-minute
sketch. Sketching the pose, rather than just looking at it, quickly
brings to light any deficiencies or impracticalities, such as the
model shifting position—a small but important consideration.
And of course it is much easier to make changes at this stage.

learn from the professionals: movement

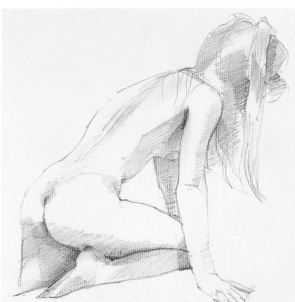

Woman kneeling • Isabel Hutchison (graphite pencil)
The model was asked to move around and then rest in a pose of her own choosing for 20 minutes. This is a good warm-up exercise, avoiding a contrived, static pose. The artist uses light hatching to describe the fall of light and tone, particularly on the hair, capturing the transitory nature of the posture.

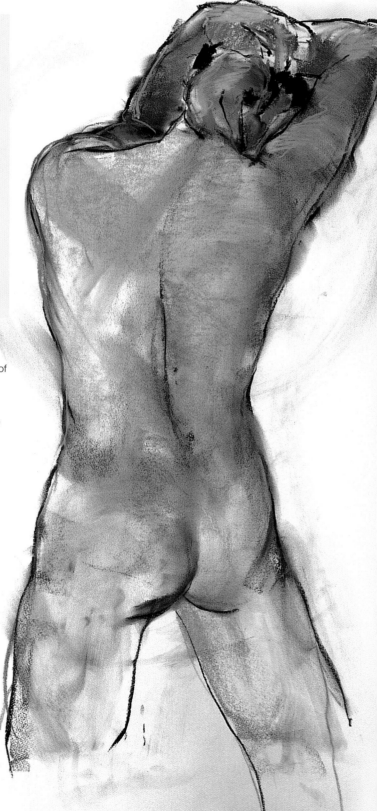

Male figure • Cloe Chloherty (charcoal and chalk pastel)
A 15-minute sketch is made of the figure, blocking in tone with charcoal and pastel and then modeling the muscular structure by blending the medium with the ball of the hand. The excess was brushed off around the top half of the torso to suggest the circular twisting movement here.

Clothed woman • Mark Topham (graphite pencil)
These five-minute sketches use simple outlines and light hatching to describe tone.

Woman in dress • Elinor Stewart (charcoal)
The figure slowly rotated on the spot enabling the artist to make these quick sketches in thick charcoal stick.

In motion • David Cottingham (conte chalk, acrylic wash)
The artist reworks the drawing as the model moves in a dance sequence filling the page with dynamic movement.

the head

theory

If the human face appears in any drawing it will always be the focus of attention.

The expressiveness of the face and the range of individual characteristics make this relatively small area of the head or "portrait" study a source of everlasting fascination to the artist—and, not surprisingly, the area of most concern. The overall proportions and structure of the adult head remain fairly consistent, and this should always be the starting point before adding the facial details. By making a very simple grid plan over the basic egg shape formed by the head, you will be able to plot the position of the facial features accurately. To ensure a true likeness to the model the slope of the jawline, width of eye placement, height of forehead are much more important factors to establish at the start than the color and shape of the eyes or fullness of the cheeks or lips.

A frequent mistake is to place the features too high up—they actually fall within the bottom half of the head. The placement of the features in a head viewed from a foreshortened angle may seem particularly difficult to tackle, but again, if you lightly sketch in some simple guidelines at the beginning, your task will be made much easier. The curving guidelines will help you draw your features so that they follow the shape of the head, and avoid making the mistake of drawing them on a flat plane.

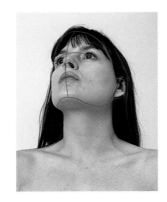

Use horizontal and vertical guidelines on the head to position features viewed at a foreshortened angle.

Profile • Isabel Hutchison *(color pencil)*
This profile study contains enough color information to work up into a finished portrait painting at a later time.

drawing figures

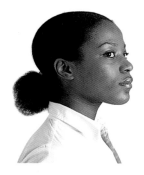
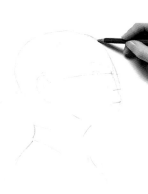

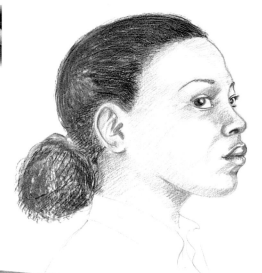

Claudine • Lucy Watson *(charcoal pencil and charcoal)*
The head can be seen as a simple egg shape. Bisect this horizontally in the middle to give you a guideline on which to place the eyes and then vertically to place the nose and mouth.

Miss Annie (Browne) • Doug Dawson *(chalk pastel)*
The artist has worked with an interesting range of colors, blending and highlighting to create a charming picture with a real sense of serenity. You can see the quiet, pensive mood of the model in the angle of her head and the set of her facial features.

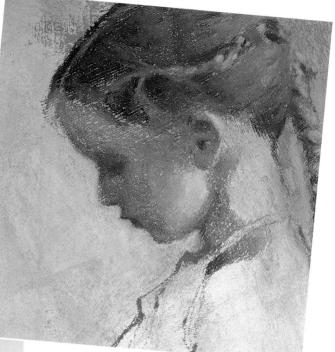

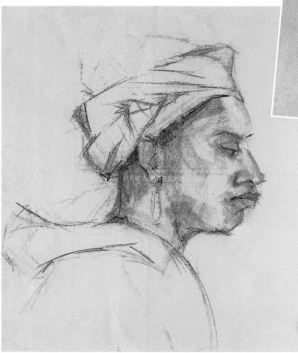

The head in profile • Barry Freeman *(chalk pastel)*
Seeing a head in profile significantly accentuates its underlying structure. The height of the forehead, the overhang of the eyebrows, the setting of the eyes, the slope of the nose, and the protrusion of the lips and chin are all seen much more clearly from this aspect.

constructing the head

Length of pose	45 minutes

media
Drawing paper
Charcoal pencil
Conte pencil
Colors
 burnt umber
 red brown

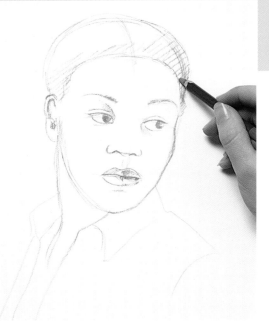

Although the facial features are unique characteristics of the subject, it is essential to see them within the context of the head as a whole.

32

drawing figures

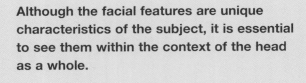

Step 1 Sketch the head in as a basic egg shape. Add two guiding lines, similar to lines of latitude and longitude. The first bisects the egg shape horizontally through the center. Now bisect vertically: This line will run down the center of the nose and mouth. These guidelines will help you correctly position the features on the head.

Step 2 Lightly draw in the position of the eyes in brown conte pencil, making sure they are not too close together or far apart. Sketch in the eyebrows. Now draw in the nose and the mouth; the parting between the lips should curve around as it covers the teeth. Draw in the upper and lower lip. Follow the horizontal guideline around—the tops of the ears are almost level with the eyebrows, so mark them in at this level and work downward filling in the ears as elongated ovals. Lastly draw in the hairline: This follows the curving shape of the forehead and frames the top of the face.

TECHNIQUES

hatching and cross hatching, see page 114
tonal work, see page 115

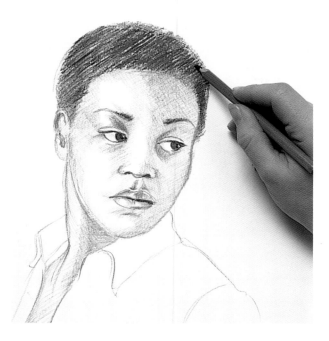

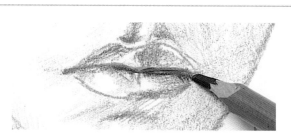

DETAIL: THE MOUTH

Use the charcoal pencil to add dark accents to deepen the parting between the lips. With the brown conte pencil, shade in the top lip and just under the bottom lip. Leave the bottom lip free of shading as it catches the light.

Step 3 You can now start to make the features look more 3-dimensional with lightly hatched areas of tone. Start on the forehead and work your way down the shadowed right side. Stand back from your work and squint if necessary to define the lightest and darkest areas. Start to work up the definition of the neckline of the shirt and hatch some tone on the neck and the hair with the charcoal pencil.

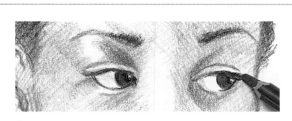

DETAIL: THE EYES

Lightly hatch with brown conte pencil to define the shadow that falls beneath the eyebrow and under the eye to accentuate the shape of the eye socket. Fill the pupil in charcoal pencil and the iris in brown conte, leaving just a spot of white in the eyes to enliven them and prevent them sinking back into the head. Lightly hatch in the eyebrows in charcoal pencil, following the direction of the delicate hairs.

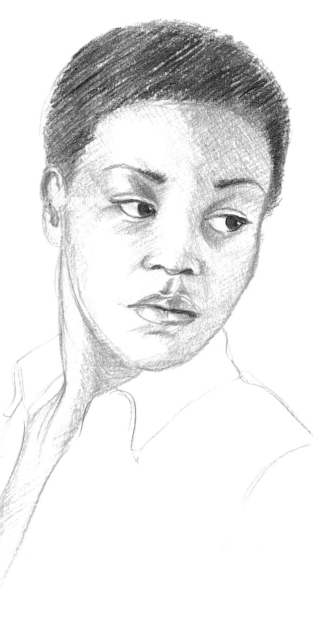

Step 4 Work up the darkest areas by adding a second layer to "cross" hatch over the first, particularly around the eyes, under the nose, and on the neck. Add more definition to the neckline of the shirt and hatch more tone on the neck.

objectives • Laying down tones in chalk pastel and using your finger to blend

portrait study

Length of pose	2 hours

media
Light-toned pastel paper
Charcoal pencil
Chalk pastel
Colors
 yellow ocher (light and dark tint)
 burnt umber (light and dark tint)
 burnt sienna (light and dark tint)
 madder brown
 rose madder
 Indian red
 Prussian blue
 black
 white

The three-quarter angle enhances the 3-dimensional modeling of the face. The model has a Mediterranean complexion so the tones selected fall in a mid-key range of dark and pale browns, warm terracotta reds, and creamy yellow highlights. Once the main lights and dark tones are laid down, a patchwork of various colors is applied in a daublike fashion and is blended together to create the skin tone.

34

drawing figures

Step 1 Make a sketch of the head in charcoal pencil. Place the eyes so their lower edge is halfway down the face. Note the position of the left eye: The outer edge almost touches the outside contour of the face while the inner side of the eye lies just on the line marking the top of the nose. The nose slopes down from the left eyebrow, jutting out to protrude from the face. Lightly sketch in the lips beneath the nose; finally sketch in the hairline to frame the face.

TECHNIQUES

 sketching, see page 115

 blending, see page 119

 blocking in, see page 119

 tonal work, see page 115

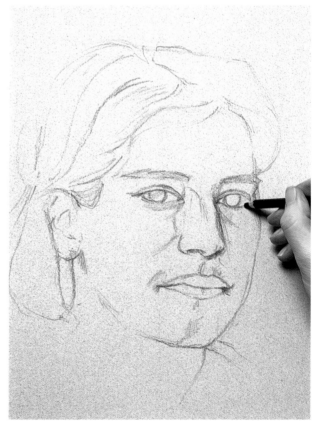

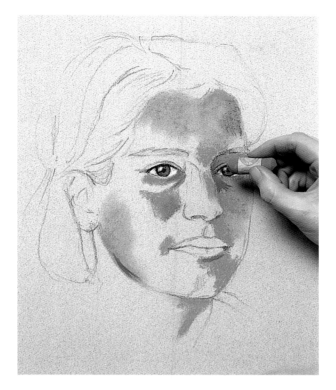

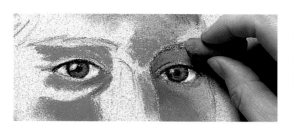

DETAIL: EYES

Use a soft carbon pencil to add fine details. Draw around the iris to define shape. Fill in the pupil. Define the smooth arch of the upper eyelash. Add white to form a bright spot of highlight to enliven the eye and give it a glassy appearance.

Step 2 Start to lay down the first shades of skin tone on the face. Use just low tones to begin with, to form an underlay describing the darker areas. Apply dark tint burnt sienna to create the tones for the darker shadowy areas around the eyes, and light tint burnt sienna to create a mid-tone coloring over the forehead and side of the right cheek, and lastly a dark tint burnt umber to fill in the eyes.

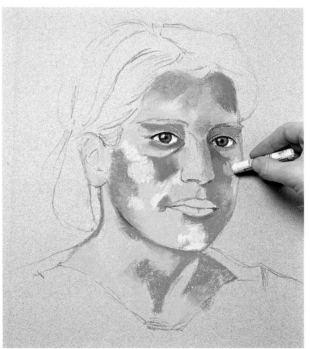

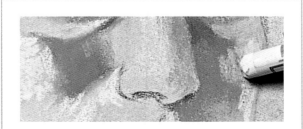

DETAIL: CHEEKS

Work up a patchwork of warm colors to describe the tones on the cheek: Indian red, madder brown, burnt umber, burnt sienna, light yellow ocher, dark yellow ocher, applied in rough daubs ready to be blended together in the next stage.

Step 3 Now stand back from your work and squint to define the highlighted areas. Add these in a light tint of yellow ocher where the light cast from the left catches the contours of the face. Bring some warmth to the right cheek and left side of the forehead by adding madder brown.

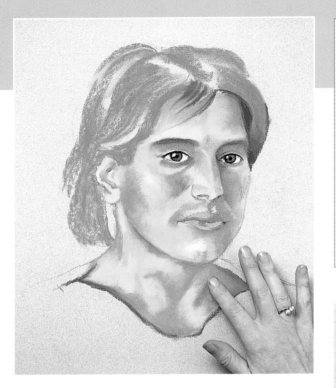

Use light rose madder to describe the highlighted area of the top and bottom lip and dark tint of rose madder to describe the darker areas, in the parting of the lips and the left side of the upper lip as it moves around into shadow.

Step 4 Add some light tint of burnt umber to the hair, using the pastel on its side and sweeping it down. Add dark accents to the eyebrows. the wisps of hair on the forehead, and the neckline of the shirt in dark tint of burnt umber. Stand back from your work and take a good look at the model and your drawing. Once you are sure all the main tonal areas are in the right place, gently blend them with your finger.

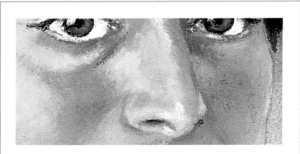

DETAIL: NOSE

Three main tones, a light, mid, and dark, are used on the nose. The mid tone of Indian red falls on the right side, and light tint of burnt umber describes the darker side that falls in shadow. The brightest highlight follows down the ridge of the nose and above the nostril in light tint of yellow ocher.

Step 5 Darken the hair with another layer of dark tint burnt umber, blending again with your finger in downward sweeps. Add some pale streaks of highlight in yellow ocher, blending in the same way to capture the reflection of light and suggest its smooth glossy texture.

Step 6 Finish the portrait off by working in the colors of the striped top in white, Prussian blue, Prussian blue worked over black to make a dark blue, and a light tint of burnt umber for the brown coloring.

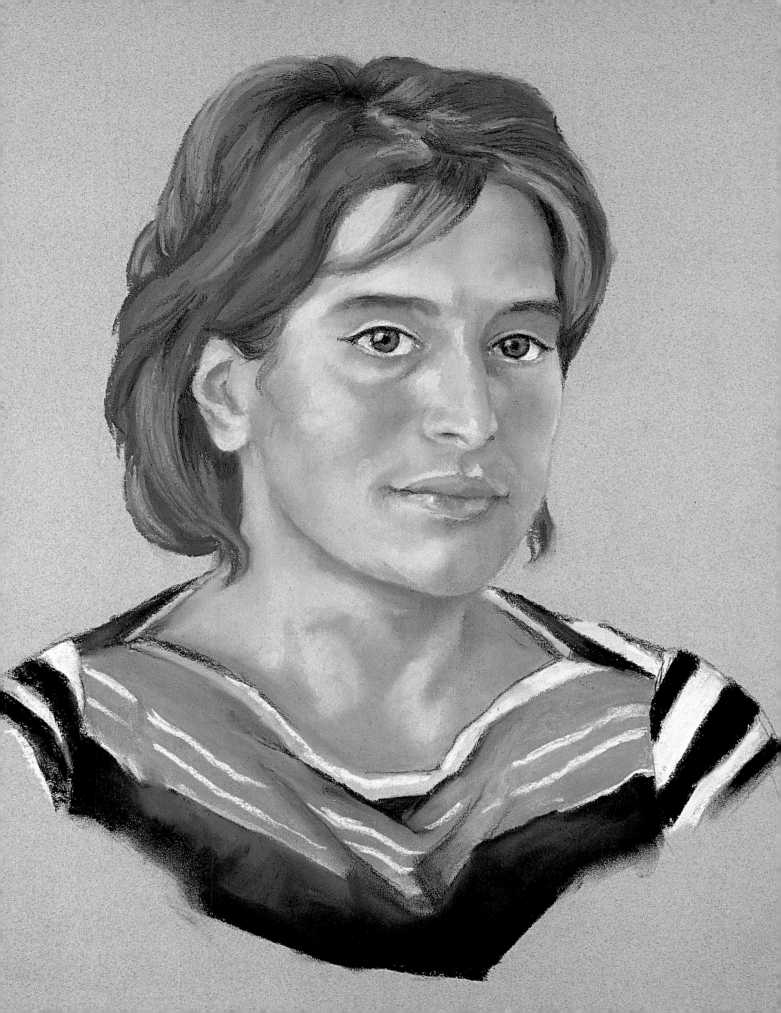

learn from the professionals: portraits

Portrait of Eva • Lorna Marsh *(chalk pastel)*
The gray ground of the paper provides the mid tone to the hair and face while tiny touches of white are used to pick out just the brightest highlights. Keeping the use of white highlights to a minimum helps retain their impact.

Face of old man • Stephen Crowther *(graphite pencil)*
The artist focuses on detail to describe the elderly sitter. Using a semi hard pencil, an HB for example, the bone structure is delicately described in light tonal shifts of hatching around the eye sockets, cheekbones, and nose, while fine lines describe the furrowed skin texture on the forehead.

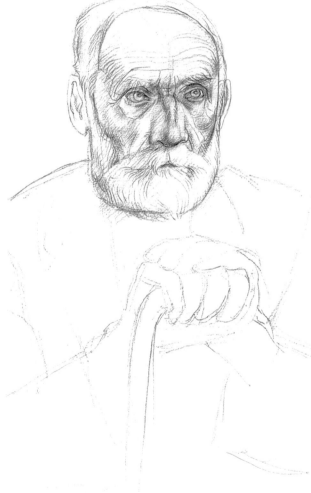

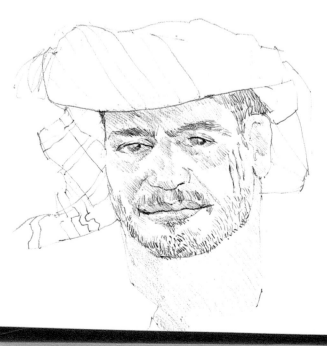

Man with turban • Ruth Geldard *(graphite pencil)*
Hatching defines the heavy sculptural contour of the features while rough dashes describe the coarse, stubbly texture of facial hair in this quick yet visually strong sketch.

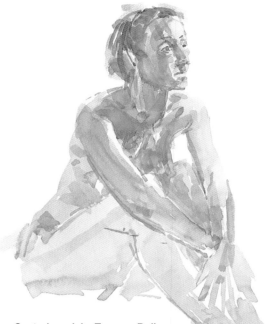

Veronica • David Cottingham *(conte chalk)*
The gentle contour and tone of this portrait are delicately modeled by drawing the figure's outline in bold strokes and then filling in dark areas and highlights.

Seated model • Terence Dalley
(watercolor)
Just two dilute washes of burnt umber and cobalt blue create all the delicate tonal variations of this portrait study in watercolor.

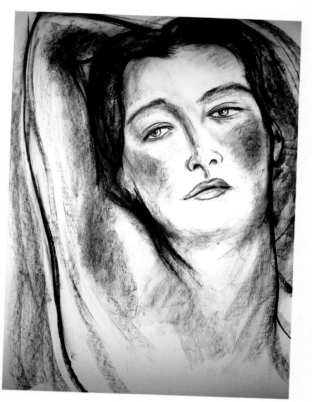

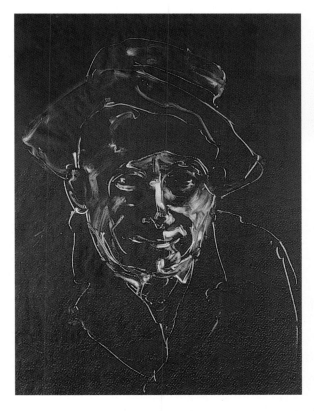

Monoprint • Lucy Watson *(printing ink)*
This stylish image was achieved by a simple printing process: Roll printing ink over a metal plate, then draw in the image with a finger and a rag, lay paper over the top, and press a print.

hands and feet

theory

Like the rest of the body, the hands and feet can be reduced to simple shapes to help you understand their form and structure.

The hands are enormously expressive and like the face can be a great focus of attention, articulating mood and intention by gesticulation. Finding the negative spaces between the fingers helps position them correctly—try draping a black piece of fabric behind the hands to bring these out. The feet are less expressive but are an important aspect of figure movement and balance. Making some separate studies of the hands and feet will familiarize you with their form and illustrate how foreshortening can affect their appearance. A useful beginners' exercise is to copy the hands and feet from a painting or drawing. Take a postcard of a Raphael, Leonardo da Vinci, or Michelangelo—reproducing these will help you see how the 3-dimensional effect is recreated in two dimensions.

A frequent mistake in figure drawing is to leave the hands and feet until the end, this makes them look stuck on—always include them with the flow of the whole drawing.

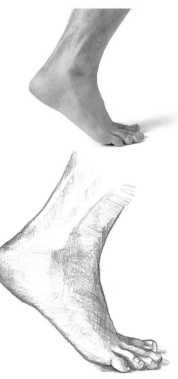

**Open hand •
Lucy Watson** (conte pencil)
Areas of light and shadow describe the 3-dimensional form of the hand.

On tiptoe • Lucy Watson
(conte pencil)
The hatched lines delicately model the form of the foot.

Reaching hand • Lucy Watson (graphite pencil)
Strong highlights and shadows bring dramatic effect to this study of the foreshortened hand.

Girl holding a fan • Paul Gauguin *(oil)*
Gentle color shifts beautifully describe the serene quality of these hands.

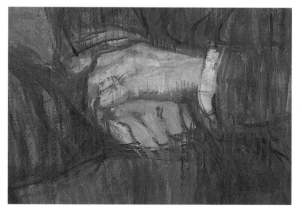

Portrait de Paul Leclercq • Henri de Toulouse-Lautrec
(pastel)
A roughly applied medley of colors brings texture and life to this study.

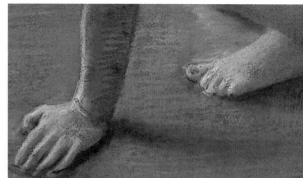

Le Tub • Edgar Degas
(pastel)
Bright, carefully placed highlights along the fingers and toes sculpt their form and make them stand out against the flat background.

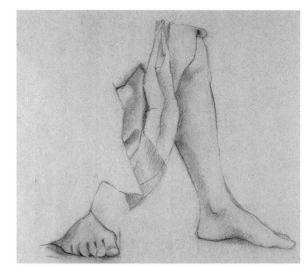

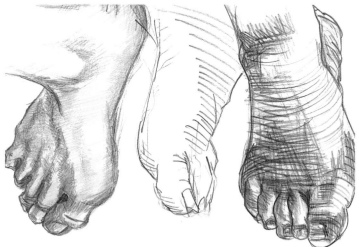

Legs and feet • Isabel Hutchison *(graphite pencil)*
This linear sketch is transformed by delicate shading that really draws out the 3-dimensional form of the limbs and drapery.

Study of feet • Lucy Watson *(color pencil)*
Practice different drawing techniques using your own feet as the model. This sketch was completed balancing a sketchbook on the artist's lap.

objectives • Learning to observe and interpret areas of light and shade • Rubbing back to create highlights and details

drawing hands

Length of pose	30 minutes each

media
Drawing paper
Sanguine pencil
Charcoal
Charcoal pencil
Kneaded eraser

With its ever-changing form, the hand is the most versatile part of the human body. These following poses illustrate two very different views of it: First, a simple, linear image of the back of the hand and pointing digit; second, the ball of clasped hands with its melee of fingers.

POINTING HAND

The hand is presented in two planes. The first plane is the back of the hand ending at the knuckles, the second plane is the fingers. The first plane of the hand presents a flat squarish shape, from which the thumb bears off. The second is the fan of fingers: Each digit can be reduced to three small jointed cylinders. The 3-dimensional quality of the hands is enhanced by the addition of light and tone—squint to see the dark and light areas.

Step 1 Sketch in the basic structure; reduce the hand to simple shapes. A line runs from the wrist to the tip of the index finger. Look at the negative space: An L shape is formed where the little finger joins the first plane of the hand, and between the index and middle finger. The fingers are reduced to cylindrical shapes to help establish the subtle variation in their movement.

Step 2 The light and tone are quite distinct on the hand. The back of the hand is cast in shadow, along with the pointing index finger. Light hits the front of the hand, illuminating the fingers, yet as they turn away from the light they too are cast in shadow. So add your first layer of hatching to these tonal areas, following the gentle curves of the hand on the first plane and down the edges of the cylindrical-shaped fingers to enhance the sense of three dimensions.

Step 3 To finish the drawing add cross hatching on the darkest areas of shadow. You will see the third joints of the middle and fourth fingers are in shadow. The knuckles cast long shadows onto the back of the hand, and the wrist joint is defined by a small deep shadow where it joins the hand.

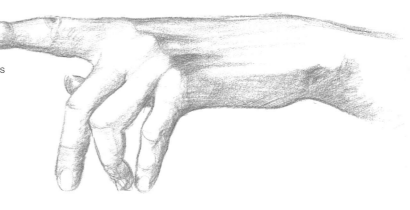

TECHNIQUES

 hatching, see page 114

 cross hatching, see page 114

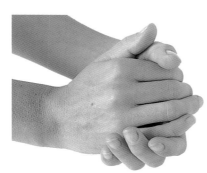

CLASPED HANDS

Drawing the two hands together can express so much—take Dürer's beautiful rendition of hands at prayer, for example. You might think that it would be more difficult to draw two hands than one hand. In fact, the two hands together can provide more clearly defined and bolder shape relationships than when seen alone, as the next exercise demonstrates.

TECHNIQUES

 sketching, see page 115

 tonal work, see page 115

 blocking in, see page 116

 blending, see page 116

 highlighting with an eraser,
 see page 117

Step 1 Lightly sketch in the outline of the hands in charcoal pencil. (Don't worry if you make a mistake, simply wipe away the wrong mark with your finger and try again.) These hands form a large ball-like shape. The fingers are compressed together so there are no negative spaces. The jointing of the fingers is the most important aspect of this piece; the fingers hug the shape of the cupped hand so in most cases only two joints of each finger are visible. Sketch in one finger at a time, working from the index finger outward so the fingers fall behind each other in turn.

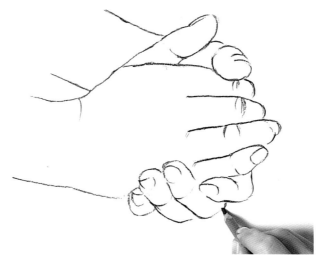

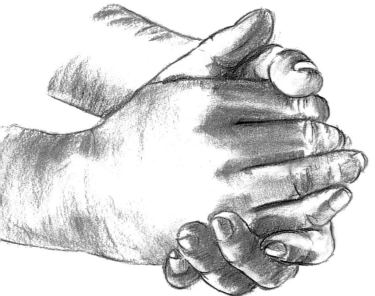

Step 2 The addition of tone will enhance the sense of three dimensions. Lightly add tone with a charcoal pencil, starting with the tonal areas on the fingers and thumbs. Now use a thin stick of soft willow charcoal on its side to block in the tonal areas on the fingers, back of the hand, and wrist. Blend them with your finger: They will lighten to make a soft mid tone. With the charcoal pencil define the dark lines of the fingers and fingernails. Use a pointed kneaded eraser to lift out small highlighted areas on the joints and tips of the fingers.

objectives • Learning to observe and interpret areas of light and shade • Drawing the figure accurately • Rubbing back to create highlights and details

drawing feet

Length of pose	30 minutes each

media
Drawing paper
Conte pencil
Charcoal pencil
Charoal
Burnt umber pencil

The feet are not as complex as the hands, but are often viewed at foreshortened angles. The top of the foot can be described as a blunt wedge shape with a fan of toes to aid stability. Tonal shading will help to express their form, so pay particular attention to the fall of light and shadow over them.

FORESHORTENED FOOT
Seen foreshortened like this, the foot presents an odd-looking shape. However, the addition of some tone soon transforms it to something more familiar.

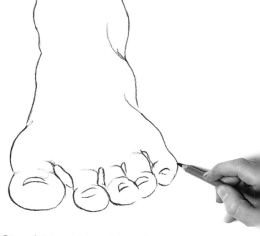

TECHNIQUES

sketching, see page 115

hatching, see page 114

blocking in, see page 116

smudging, see page 117

Step 2 Hatch the darkest areas of tone. Shading in the area between each toe and hatching up the left side of the foot achieves a sense of depth. Now break about an inch (2.5 cm) off a slim willow charcoal stick. Use it on its side to roughly block in the tone over the top of the foot and up the ankle. Break the stick again to work a very small piece over the individual toes. Smudge the areas of finer detail around the toes. Retain the white highlights which run centrally down the ankle and over the foot, as well as on the toes, to retain their cylindrical appearance.

Step 1 Use a charcoal pencil to sketch in the outline of the foot. The toes from this perspective look like five bulbous shapes, but the addition of the nails helps to describe the foreshortening of the upper sides.

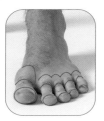

UNDERSIDE OF THE WALKING FOOT

Drawing the underside of the foot seen from behind is quite a challenge—especially if you are to successfully capture the 3-dimensional form that is the essence of the image. Start by reducing the foot to its basic shapes: Curved bands over the toe are supported by the semicircle of the ball of the foot. This stretches into the parallel lines of the underside and up to the circle of the heel.

Step 1 Draw a simple outline of the foot, noticing how it expands from the ankle into a large wedgelike shape balanced on the toes that stabilize it as it touches the ground.

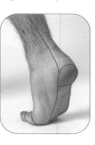

Step 2 Shade in the darkest tonal areas to build up a sense of form. Use hatching and cross hatching to follow around the curves and deepen the shadows.

TECHNIQUES

hatching, see page 114

cross hatching, see page 114

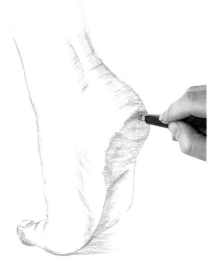

Step 3 Work over the hatching again, using a little more pressure, to darken the darkest areas—squint to help you see where these are. Some shadow definition around the ankle and heel conveys the tension of the flexing muscular movement. Add finer details to the toes, defining the toenails and adding a little shadow beneath the foot to root it to the ground plane.

objectives • Defining volume using directional hatched lines

tonal study

Length of pose	1 hour

media
White drawing paper
3B pencil
7B pencil
Kneaded eraser

The pose was arranged to show a downward spiraling movement from the head to the toes, echoed in the casually twisting drapery around the chair back and legs. Gentle lighting from the left casts shadows onto the model's back so a large area of soft tonal shading could be worked up in the drawing.

TECHNIQUES

sketching with a pencil, see page 114

hatching, see page 114

cross hatching, see page 114

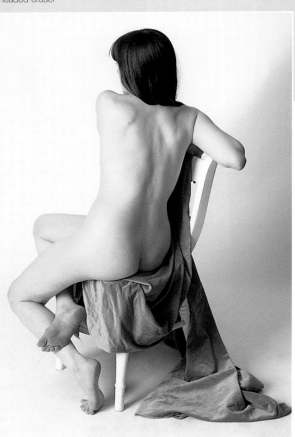

Step 1 Lightly sketch in the contour of the figure and the drapery. Try to work in smooth fluid lines without lifting your hand too frequently from the paper. Follow the flow of downward movement, through the sleek hair sweeping over the shoulder, down the gentle twisting torso, into the left leg which ends in a smooth S shape formed by the sole of the foot.

UNDERSIDE OF THE WALKING FOOT

Drawing the underside of the foot seen from behind is quite a challenge—especially if you are to successfully capture the 3-dimensional form that is the essence of the image. Start by reducing the foot to its basic shapes: Curved bands over the toe are supported by the semicircle of the ball of the foot. This stretches into the parallel lines of the underside and up to the circle of the heel.

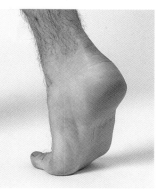

Step 1 Draw a simple outline of the foot, noticing how it expands from the ankle into a large wedgelike shape balanced on the toes that stabilize it as it touches the ground.

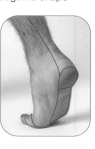

Step 2 Shade in the darkest tonal areas to build up a sense of form. Use hatching and cross hatching to follow around the curves and deepen the shadows.

Techniques

hatching, see page 114

cross hatching, see page 114

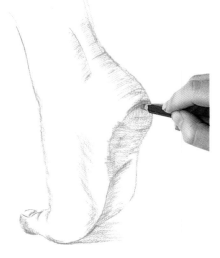

Step 3 Work over the hatching again, using a little more pressure, to darken the darkest areas—squint to help you see where these are. Some shadow definition around the ankle and heel conveys the tension of the flexing muscular movement. Add finer details to the toes, defining the toenails and adding a little shadow beneath the foot to root it to the ground plane.

light and tone

theory

Light effects and tonal shadows add an exciting element to any drawing.

Adding even a minimal amount of tone to a line drawing will enhance the sense of the mass and volume of a 3-dimensional figure. Gentle natural lighting enhances delicate tonal variations of muscular structure, and can be sensitively worked in hatched and cross hatched lines ideally suited to pen and ink, pencil, or conte pencil. Watercolor works particularly well with natural lighting, as delicate washes can be applied in transparent glazes to build up its glimmering, ever-changing effects. In contrast, artificial illumination is static and constant. A strong directional beam cast from a lamp can create dramatic impact by creating powerful light and dark areas. This is ideal for work with charcoal, chalk, and oil pastel as broad areas can be worked up easily. Avoid lighting your subject from a number of different sources, or mixing natural and artificial lighting, as this casts visually confusing effects.

You will find your style will lean toward dramatic or subtle. It is worth trying out different media to find which feel most comfortable; or experimenting with two contrasting media in the same work, a delicate one (ink wash) and a coarser one (chalk pastel) for example, as this can lead to some unexpected and welcome discoveries.

Seated woman • Terence Dalley (watercolor)
Transparent washes are layered on top of one another to produce dappled tonal effects on the torso.

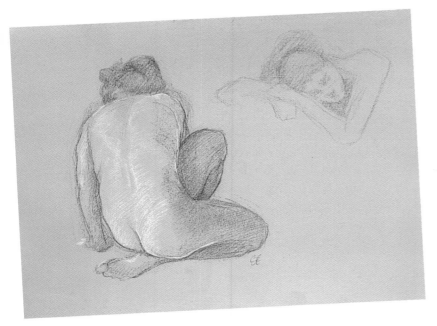

Crouching • Clarissa Koch *(carbon and conte pencil)*
Delicate shading with a carbon pencil and white conte pencil
on toned paper evokes the rounded, sculptural form.

To get a good idea of the effect of lighting, take your sketchbook outside on a sunny day and record how sunshine hits the subject and casts shadows. Performing the same exercise on a dull day will produce very different results as the lighting is subtle and the tonal contrasts between light and shadow barely distinguishable. Try experimenting with artificial light—a flashlight will do: Look in the mirror and illuminate your face from various angles. Uplighting from your chin will create a dramatic impression, similar to theater footlights.

Standing woman • Neil Suckling
(graphite pencil)
Just a hint of light hatching in pencil
on the edge of the contour suggests
the 3-dimensional form of the figure.

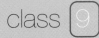

objectives • Defining volume using directional hatched lines

tonal study

Length of pose	1 hour

media
White drawing paper
3B pencil
7B pencil
Kneaded eraser

The pose was arranged to show a downward spiraling movement from the head to the toes, echoed in the casually twisting drapery around the chair back and legs. Gentle lighting from the left casts shadows onto the model's back so a large area of soft tonal shading could be worked up in the drawing.

TECHNIQUES

 sketching with a pencil, see page 114

 hatching, see page 114

 cross hatching, see page 114

drawing figures

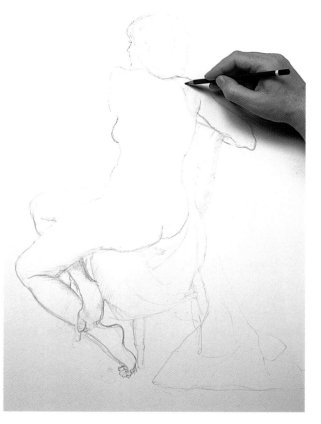

Step 1 Lightly sketch in the contour of the figure and the drapery. Try to work in smooth fluid lines without lifting your hand too frequently from the paper. Follow the flow of downward movement, through the sleek hair sweeping over the shoulder, down the gentle twisting torso, into the left leg which ends in a smooth S shape formed by the sole of the foot.

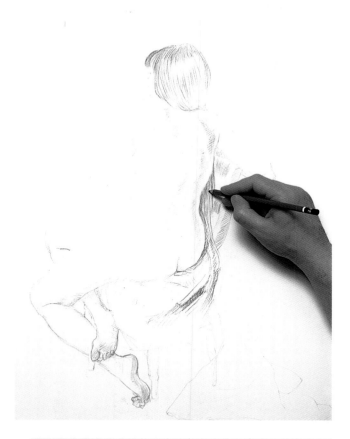

Step 2 When the contour is complete, look carefully at the shadows on the figure. They are particularly striking on the back where the light and tone gently "mold" the sinuous contour of muscle between the shoulder blades and along the spine. Starting with a 3B pencil, add the first layer of hatching, describing the gentle undulations with your hatched lines. Work over the entire figure and the drapery in the same fashion to achieve a sense of unity and accentuate the grace of this pose.

TIP

Imagine your pencil is a sculptor's spatula and you are "modeling" the form of the figure, as the hatched lines flow with the direction of movement.

Step 3 Change your pencil to a softer 7B and cross your original hatching to work up the darker tonal areas. This will increase the sense of the 3-dimensional form as the contrast between light and tone intensifies. The areas of tone are particularly evident on the back and within the folds of drapery. Darken the shading on the hair with smooth downward sweeps with the pencil. The model's hair reflects more light than any other part of the body, so barely touch the highlights with the pencil.

Stand back and take a good look at the drawing and the model. Squint if necessary to define the light and dark areas. If you discover any area of highlight has been lost under hatching, use an eraser to clean away unwanted pencil marks. Finally, add a layer of cross hatching to emphasize the darkest areas of shadow.

objectives • Using light to enhance the sense of form and volume on the figure

shadow and highlights

Length of pose	30 minutes

media
White conte pencil
2B pencil
7B pencil
Smooth mid-gray drawing paper

A striking figure work can be created using just three tones. A soft graphite pencil defines the area of shadow, a white conte pencil provides the highlights, and a mid-gray paper gives a neutral body tone. This method is excellent practice for working with chalk or oil pastel on toned papers, or preparatory work for painting in oils.

Dramatic light from a lamp from the left throws the right side of the body into shadow. The model is turned toward the light to show off the eye-catching undulation of form where light and shadow meet.

drawing figures

Step 2 When you are satisfied the contour is complete, think just of light and dark tone; squinting to look at both the model and your work will help eliminate any mid-tone. Draw the outline of the shadow areas and lightly fill them in with a flat tone by hatching with a 7B graphite pencil.

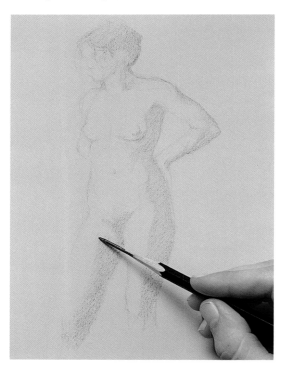

Step 1 Lightly draw the outline of the figure with a 2B graphite pencil. Do this very loosely so that any small alterations can be made at this stage as the model settles into the pose. Looking closely at the negative space between legs and left arm will act as a guide to positioning these limbs.

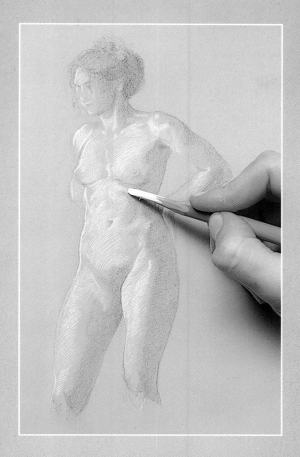

Step 3 Now lay in the highlights with the white conte pencil. Look for the lightest areas on the figure first: These usually appear where the bone becomes visible under the flesh. The collarbone, top of the shoulder, and lower ribcage are particularly prominent in this pose. Draw fine white hatched lines to describe the fall of light on these "sharp" areas.

TECHNIQUES

 hatching, see page 114

 cross hatching, see page 114

 highlighting, see page 117

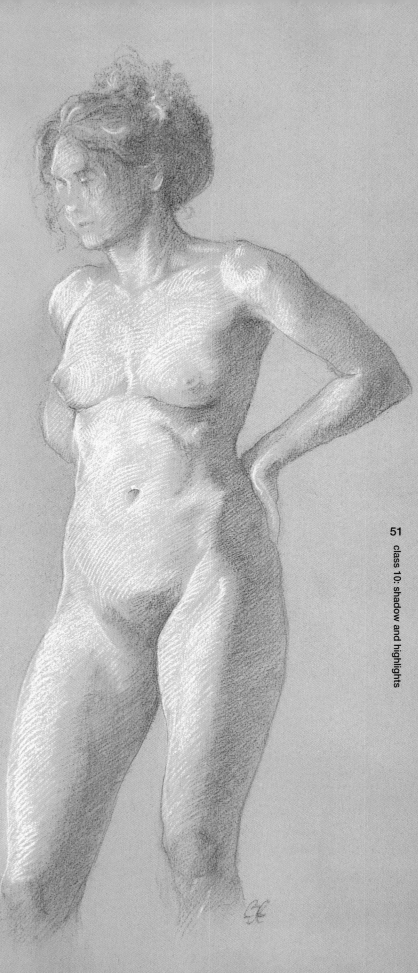

Step 4 Then work up the larger areas of light over the figure, by gently hatching with the conte pencil following the form of soft undulating flesh over the face, torso, and legs.

learn from the professionals: light and tone

**Woman sitting back on hands •
Terence Dalley** *(watercolor)*
By leaving the watercolor paper
untouched, a line of bright
highlight is retained down the
right side of the torso to
emphasize its rounded form.

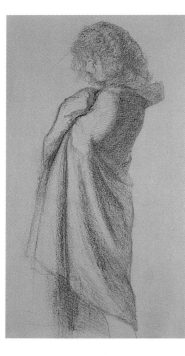

**Woman with head bowed •
Isabel Hutchison** *(graphite pencil)*
The artist delineates the tonal area over
the body and then fills in with cross
hatching, bringing a sense of depth by
pushing the torso back into shadow.

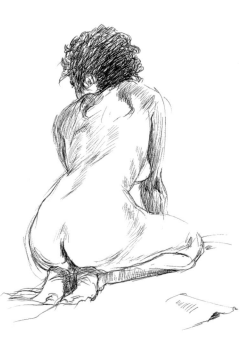

**Woman wrapped in shawl •
Clarissa Koch** *(charcoal pencil)*
Very fine hatching is worked up in
layers. Gentle and firm pressure has
been applied to the sharpened pencil
to bring out the light and dark
shadows respectively.

**Back view of kneeling woman •
Lorna Marsh** *(ink pen)*
Soft shadow on the gentle
sweeping twist of the back is
described economically in fine
hatching to make this delicate
30-minute sketch.

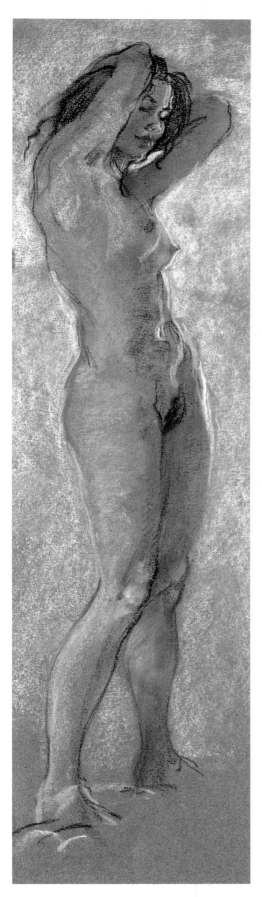

Standing figure • Lorna Marsh *(chalk and charcoal)*
The deep rose tinted paper provides a perfect mid-tone body color to which the artist simply adds touches of light and tone in white chalk and charcoal to model the form of the figure. Blocking in the background at the end of the sketch in white chalk heightens the contrast against the colored ground and shows off the figure contour.

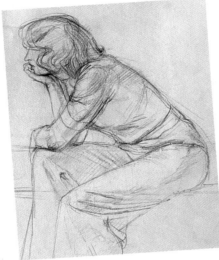

Seated woman in profile • Stephen Crowther *(graphite pencil)*
Clothing introduces a mix of tonal textures and tensions in the figure by pulling tautly over the limbs and hanging in loose folds.

Back view of female, hand on hip • Cloe Cloherty *(charcoal stick)*
The eraser is applied to the tonal areas, lifting out highlights in broad sweeps of movement to model the twisting curve of the torso. In contrast, notice how the dark tone is worked up to a rich black to describe the shadow on the foreshortened lower left arm.

color

theory

Color should be used and enjoyed in our work without the weight of theories and codes of practice.

There is an overwhelming range of commercial colors and tints available in art stores. Don't let this daunt you—rather, you should enjoy the opportunity to experiment. You will be inclined toward some color combinations: Whether a riot of color, a cool, subdued palette, or a combination of both, it is always a very personal inclination.

Color will constitute an important element in your work as it holds the power to evoke a strong sense of mood. You can, for example, go wild sketching in color on a crowded beach at the height of a summer's afternoon, when the sun bathes the scene in bright light. But to evoke the same scene in the evening under the setting sun, the colors will have to drop a few keys along with the falling temperature.

Any color can be strongly affected by another color placed beside. If clashing effects happen in your drawing, you might need to make some adjustments by toning down a color or blending with another. It is always worth taking time to consider how colors work together and how they can help you express your ideas before starting work.

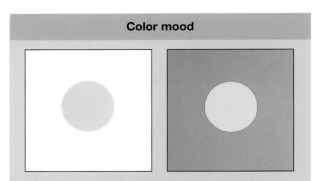

Color mood

Put a yellow circle on a white background, then on a blue one. Against a blue background the yellow is intensified as the contrast is greater, giving a much warmer feel to the image. This is because reds and oranges feel warm and give the impression of moving forward, while cooler hues, blue for example, seem to recede.

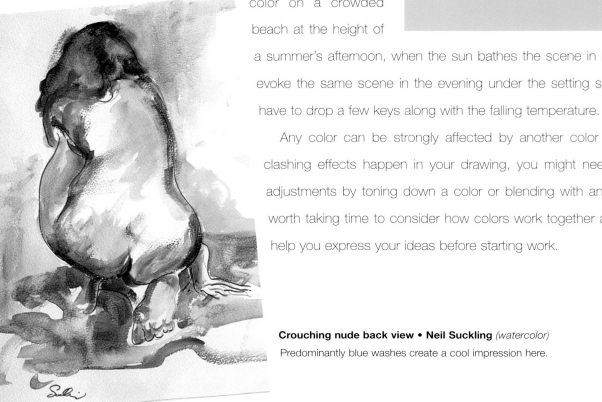

Crouching nude back view • Neil Suckling (*watercolor*)
Predominantly blue washes create a cool impression here.

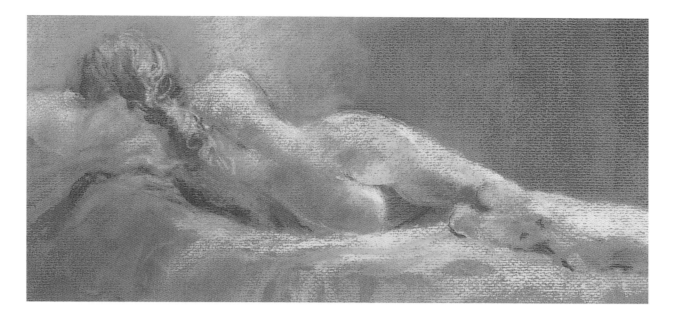

Resting on silk covers • Maureen Jordan (chalk pastel)
Warm and cool tints are combined in this evocative piece to produce accents of cool background shadow contrasting with warm highlights on the figure and bed.

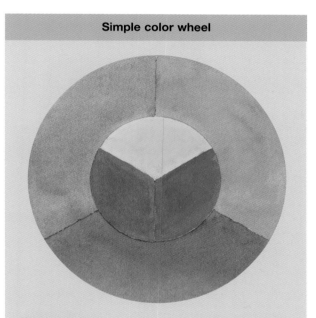

Simple color wheel

This shows the three primary colors and the secondary mixes that can be made from them. By following the wheel around, you can identify that red and yellow mixed becomes orange, yellow and blue mixed becomes green, and blue and red mixed becomes purple. Complementary colors fall directly opposite one another on the wheel: So the complementary of red is green, of yellow is purple, of blue is orange. The strong contrasts that emerge when a color is placed with its complementary can produce some striking effects in your work. Colors can also be described in terms of temperature value, feeling cool if biased toward green, blue, and purple, and warm if biased toward red, orange, and yellow.

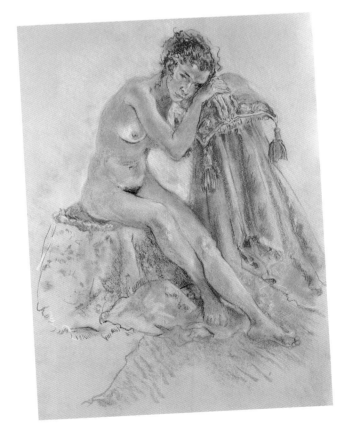

Female resting head • Lorna Marsh (chalk pastel)
Bright yellow highlights and scarlet shadows produce an intense warm feel to the reclining nude.

objectives • Describing flesh tones with color
pencil • Working up blends with cross hatching

color in flesh tones

| Length of pose | 2 hours |

media
Charcoal
Color pencils
Colors
 orange
 violet
 deep purple
 light brown
 yellow ocher
 burnt umber
 deep red
 light cream

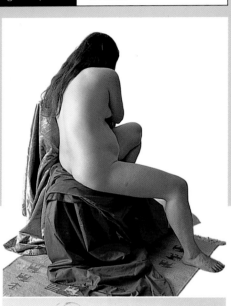

The soft lighting, the model's deep auburn
hair, and the scarlet drape invite the use of
warm, rich colors for this composition. It is a
relaxed, modest pose well suited to the
delicate color shifts that can be achieved with
color pencils. Eight were selected to work
from the lightest areas to the darkest,
hatching the colors lightly into one another.

TECHNIQUES

 hatching, see page 114

 sketching, see page 115

 blending, see page 118

56

drawing figures

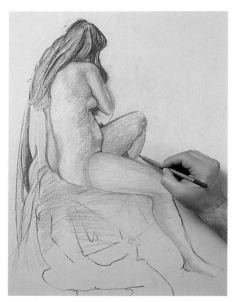

Step 1 The contour is sketched in charcoal. Look for shapes
the body presents in this pose. The torso and upper right leg
form an L shape. The thick mass of hair forms a square shape,
lying on top of the shoulders, then running off at the side. Notice
how the thigh gently squashes against the calf beneath.

Step 2 The back is bathed in light from the left, so fill in this
area by hatching with yellow ocher pencil. Keep the feeling of
warmth by working up the shadows with a violet pencil. The
right thigh catches the light at an oblique angle to create a soft
mid tone, described here in orange blended with violet.

Step 3 To add richness to the drawing, work up some blends of colors into the flesh. Gradations of deepening tone capture the move from light to dark. The bright yellow ocher light cast on the back gives way to orange, then violet, and finally into deep purple. Continue to add the darkest areas of shadow with the purple to accentuate the impression of 3-dimensional form. Lightly hatch down the center of the right leg toward the ankle to define the calf muscle in a light brown mid tone. Lastly hatch in the rest of the drapery in deep red and burnt umber pencil and fill in the hair in long sweeps, in purple, light brown, and burnt umber. Add the odd wisp straying out across the back. Stand back from your work and pick out areas of highlight that might have been lost. The breast and slight bulge of the stomach reveal the voluptuous character of the model and are picked out with a light cream pencil to create a highlighted area.

objectives • Contrasting bright vibrant colors against dark skin tone • Selecting a toned paper to form the mid-tone skin color • Working on "toothed" pastel paper

vibrant color

Length of pose	2 hours

media
Paper with a fine tooth
2B pencil
Oil pastel
Colors
 turquoise
 scarlet
 cerulean blue
 cobalt blue
 burnt umber
 warm gray
 bright green
 yellow
 orange

The emphasis here was working with vibrant colors in oil pastel. The toned paper was selected to provide the mid tone of the skin—the pastel was applied lightly to these areas to allow the paper to show through. The cushion, dress, and fabric draped on the floor were chosen to present a medley of pinks, yellows, blues, reds, and oranges against the contrasting dark skin tone of the model. A decorative scarf made a bright accent in her mass of soft black hair.

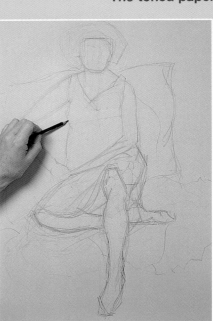

Step 1 Make a light outline of the figure in 2B pencil. Look at the negative spaces to get the positioning between the right arm and the torso. Then look at the shape the legs create: A neat cross at an almost perfect 90-degree angle. Include the "hang" of the dress.

Step 2 Begin to lightly block in the dark skin tones in burnt umber and the hair in warm gray, using the sides of the pastels. Let some of the tooth of the paper come through to retain a sense of liveliness.

Step 3 Use two shades of blue on the dress: Turquoise to define the highlighted areas on the pleats and folds, and cerulean blue to block in the tonal areas. Sketch in the fabric on the floor using fast, rough lines in scarlet pastel. The texture is smoother over the colorful cushion, so add pink, cobalt blue, and orange in broad downward sweeps.

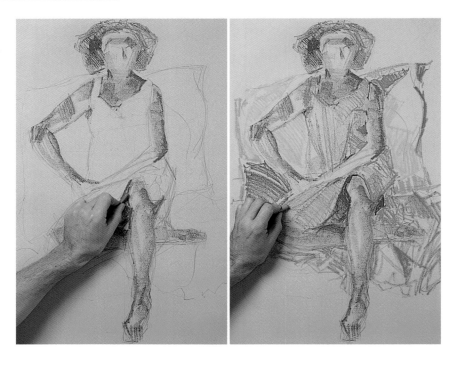

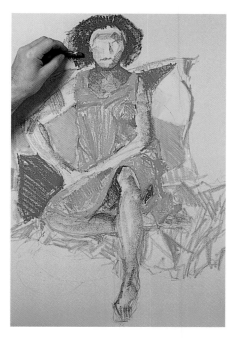

TECHNIQUES
 sketching with a pencil,
 see page 114
 hatching, see page 114
 blending, see page 120

Step 4 Stand back from your drawing and look at the light and dark tones. A soft natural light is coming in from the left so work over the skin tones lightly hatching with the burnt umber pastel, accentuating the shadow falling on the right side of the limbs. Add a little blue where the bright dress reflects onto the right forearm. Some turquoise highlights over the pleats in the dress will emphasize its high key coloring. The dark hair absorbs the light so, to describe its soft texture and prevent it becoming too heavy, allow a little of the tooth of the paper to show through the pastel, particularly around the edges of the hair.

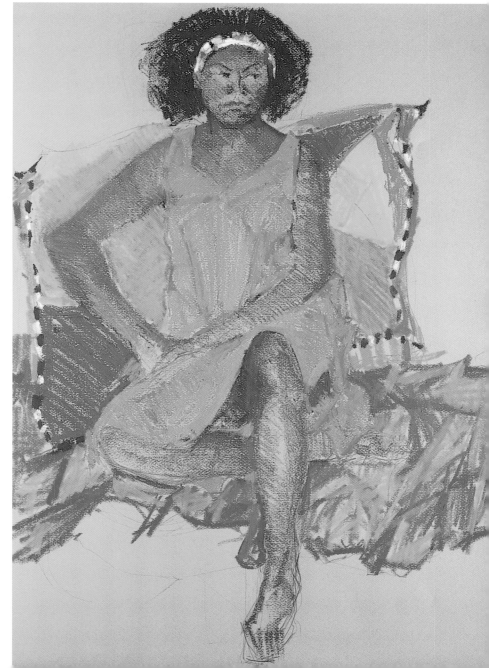

Step 5 Add some pink accents to the highlighted area on the floor fabric, in quick jagged marks. Describe the yellow and bright green shapes and black and white dashes to finish off the cushion. Accentuate the headband with dots in white, yellow, and orange. Add some shadow on the upper lip and under the chin, and a spot of white to the eyes to help them stand out.

objectives • Using delicate washes of watercolor to describe skin tone and drapery

dancer

Length of pose	1 hour 30 minutes

media
Watercolor paper
2B pencil
Watercolor paints
Colors
 cobalt blue
 neutral tint
 rose madder
 Indian red
 raw umber
 burnt umber
 burnt sienna
No. 6 round brush

Strong directional light is cast from the left on this pose, enriching the dancer's exotic costume. Light is reflected off the silk skirt in long streaks while casting deep shadows in the folds. Medallions on the bodice bring shimmering accents to the torso. The skin absorbs more light than the fabric so you might need to squint to define where the lightest and darkest areas appear on the face, shoulders, arms, and feet. Notice the delicately posed fingers.

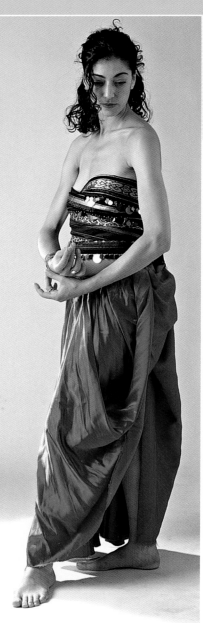

drawing figures

Step 1 Lightly outline the contour of the figure with a 2B pencil, marking in the limbs, the head, and the folds of the skirt. This will form the basic guide for the watercolor washes. Start with dilute tones of the main colors: Cobalt blue and neutral tint for the dancer's bodice and hair, rose madder and Indian red for the skirt—touch in the darkest shadows on these areas first. Then mix a delicate skin tone of raw umber and lightly block in all the flesh areas in a light wash.

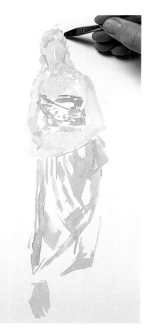

TECHNIQUES
 laying down watercolor
 washes, see page 123
 working wet on dry,
 see page 123

Step 2 Apply another layer of red wash to the folds of the skirt. Leave the edges of the pleats untouched so the white of your paper provides the highlights. When this has dried, mix Indian red and burnt umber and accentuate the deepest folds with dark broken lines following the fall of the fabric.

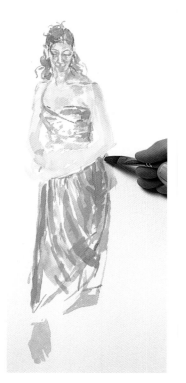

Step 3 Now use a more concentrated shade of the cobalt blue, and sweep the brush around the torso to describe the tight binding of the fabric. Retain white accents from the paper beneath on the folds and the tiny medallions on the bodice. Use a fine brush to touch in the eyebrows and the detail of the eyes, making sure you have dried off your brush on an absorbent tissue. Finally, add the loose tendrils of hair that hang over the shoulders and right side of the face.

Step 4 Apply a dilute layer of raw umber on the shaded areas on the left foot, the left side of the face and forehead, down the inside of the right arm, and along the outer side of the left arm. Wait for this to dry. Now mix up burnt sienna and apply a further layer to the darkest areas of shadow, particularly on the right forearm and outer side of the left arm. Use the same color with a fine brush to add the details on the fingers and the face, adding a little beneath the left eyebrow and left side of the nose, and a small daub on the chin. Finish off with a little red to the lips.

objectives • Blending chalk pastel colors into a charcoal sketch
• Working with complementary coloring to create vibrant effects

man playing guitar

Length of pose	1 hour 30 minutes

media
Charcoal stick
Chalk pastel
Colors
 cobalt blue (dark and light tint)
 cool gray
 deep purple
 deep red
 cadmium orange
 sap green / olive green
 burnt umber (light and dark tint)
 crimson lake (light tint)
 burnt sienna (dark tint)

This piece is worked quickly and loosely, reflecting the relaxed, transitory nature of the pose. The initial sketch is worked in charcoal with any adjustments reworked into the sketch. Bright primary colours of blue and red are added but are subdued by blending with the charcoal so the overall impression is "low key." However, each color is balanced by its complementary to create muted but luminous effects.

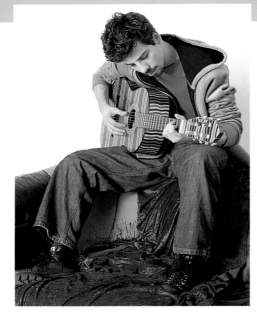

Step 1 Use a short piece of charcoal to lightly outline the contour of the sitter and then use the stick on its side to block in the areas of tone. Don't rub out any mistakes that you might make, just rework line and tone on top of one another. This layering effect adds to a sense of movement.

TECHNIQUES

 hatching, see page 114

 blocking in, see page 116

 blending, see page 119

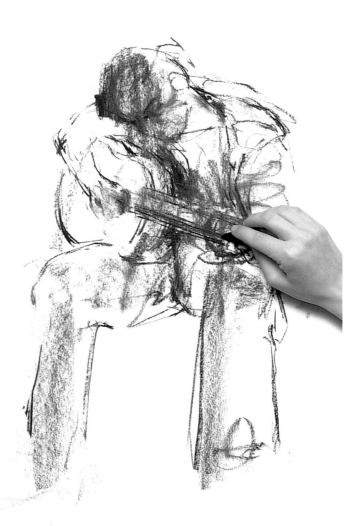

drawing figures

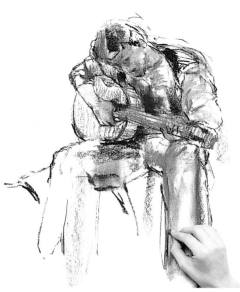

Step 2 Begin to add the skin tones to the face and arms in burnt sienna (dark tint) for the shadowed areas and burnt umber (light tint) for the highlighted areas. Use the burnt umber (light tint) again to block in the guitar and the highlighted creases on the jacket. Touch in the colors on the other fabrics: Deep red for the shirt, cobalt blue for the highlights on the jeans, deep purple for the drape. Blend the pastel and charcoal work with your finger to establish the tonal areas.

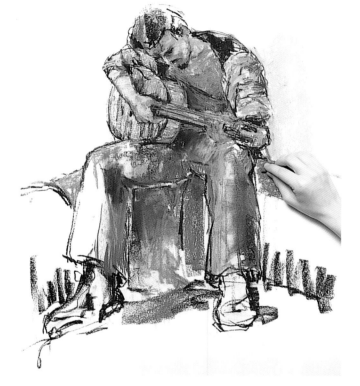

Step 3 Work over the shirt again in the deep red to make a bright accent beneath the shadowed face; pick up this color again in the drape, then add highlights to the folds in cadmium orange. Sketch in the figure's boots in compressed charcoal, and finally lightly hatch some crimson lake (light tint) on the neck and left side of the face.

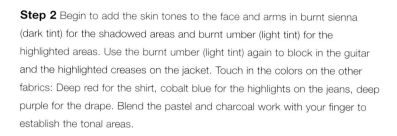

Step 4 Block in the sofa in compressed charcoal. Now fill in the boots: Add a touch of sap green to provide a mid tone and retain a small highlight on each, to prevent them disappearing into the background. Block in the background with cobalt blue (light tint). Blend a cool gray into the background on the left side to suggest a cast shadow, helping to push the figure forward. Finally add the small details: Cobalt blue (light tint) to the strings and pegs on the guitar, laces to the boots in burnt umber (dark tint), touches of olive green to the shadows on the jacket and guitar to complement the coloring on the shirt.

learn from the professionals: color

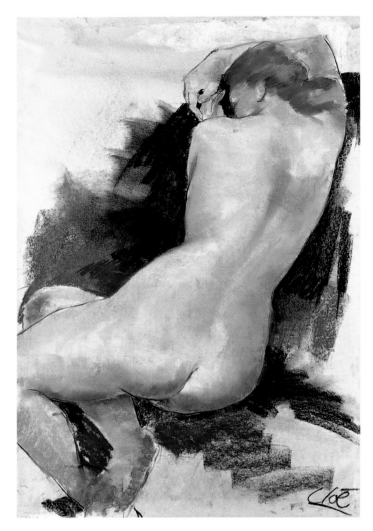

Woman with red hair • Cloe Chloherty
(chalk pastel and charcoal)
Yellow ocher, burnt umber, raw sienna, and cobalt blue are blended with the finger, emphasizing the gentle undulations of the torso. Light tint yellow ocher and white highlights are laid across the shoulders and down the left side to accentuate the sense of form and volume.

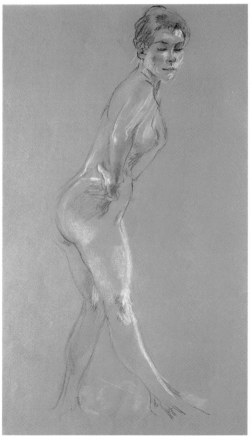

Tribeswoman • Hazel Lale
(watercolor)
Vivid red, purple, and yellow are worked wet-on-wet to create free bleeds of warm coloring to describe the tribeswoman and her ornamental jewelry. Details on the face are sharpened up with a thin brush when the work is dry.

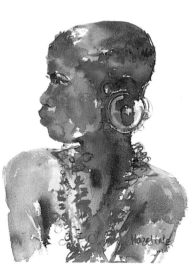

Woman leaning to the right • Lorna Marsh
(chalk pastel)
The deep mustard yellow paper provides a striking body tone to the figure, to which minimal touches of primary color with white and black are all that is required to create this lively, attractive sketch.

Girl with hair pulled back • Maureen Jordan
(oil pastel)
Layered blends of oil pastel simply but beautifully
describe the girl's face cast in shadow.

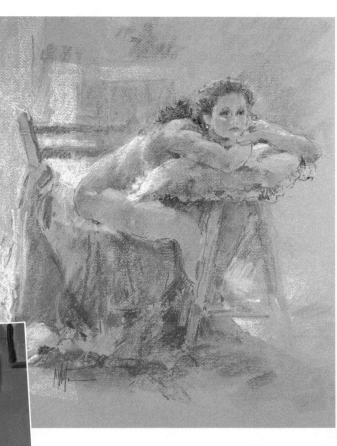

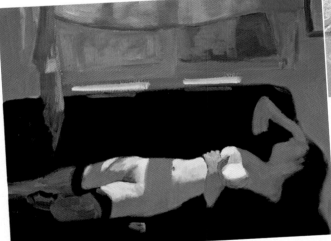

Louisa • Andrew Macara *(acrylic)*
The pastel shades of the figure and window contrast well with
the deep black of the couch, while the splash of pink curtain
brings life and energy to the piece. The highlighted areas on the
body glow brightly to give a strong feeling of warmth as the
model basks in the sun.

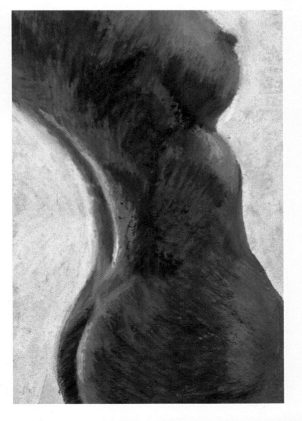

Torso • Gary Michael *(chalk pastel)*
The subtle blends of dark colors create a very intense effect in
this interesting composition.

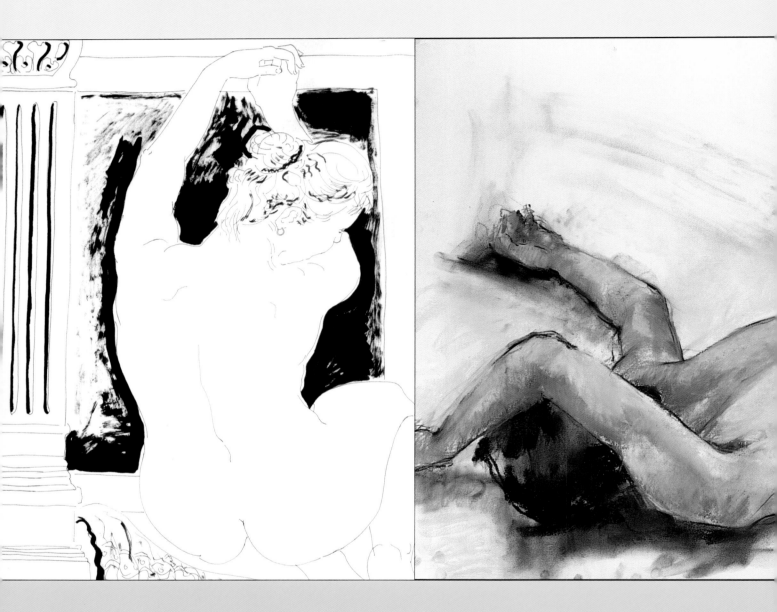

2 Creating an impression

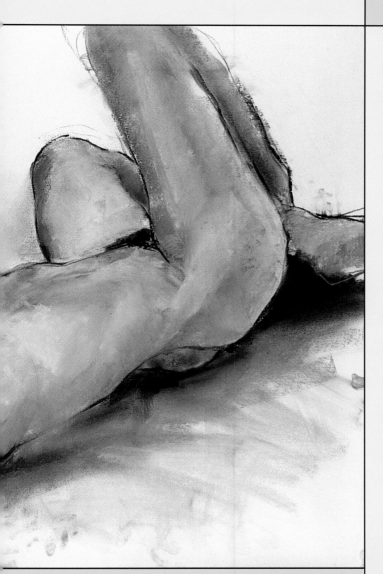

The classes have so far covered the fundamental aspects of the figure: Construction, perspective, and how light and tone contribute to the modeling of form.

Now we turn our attention to the figure as a source of expression. We consider how to manipulate lighting to exploit the best features of a pose; how to create mood in a composition; and how to decide upon the most favorable drawing angle.

You will be amazed how careful attention to such details will make the world of difference to your drawing.

lighting and mood

theory

Light and tone enhance the impression of mass and volume, and evoke a sense of mood and atmosphere.

In the seventeenth century the masters Caravaggio and Georges de la Tour used light and shade to create dramatic pictures of religious figures, while Vermeer used gentle light to create a mood of tranquil beauty in his homely figures.

Try working under different lighting conditions to discover the range of possibilities. Light from a single source, such as a lamp or candle in a darkened room, can create a theatrical effect and transform a figure. A harsh fluorescent light eliminates shadow and is very bland. Natural light streaming through a window or diffused through fabric can create gentler effects. Working outdoors presents yet more possibilities: Bright sunshine can be quite striking—bleaching colors and casting deep shadows which lengthen toward evening, changing the mood yet again.

creating an impression

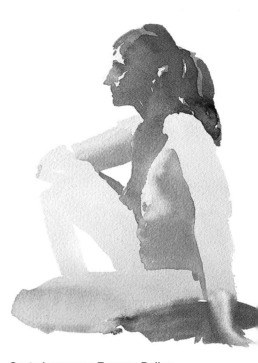

Seated woman • Terence Dalley
(watercolor)
Deep washes of tone set against lighter washes produce imposing light effects.

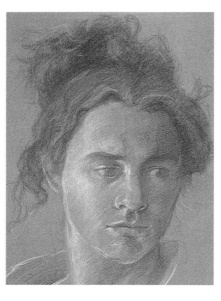

Head study • Clarissa Koch
(white conte pencil and graphite pencil)
A dark red paper provides a strong contrasting ground on which to build the striking light effects on the face, hatched in white conte pencil.

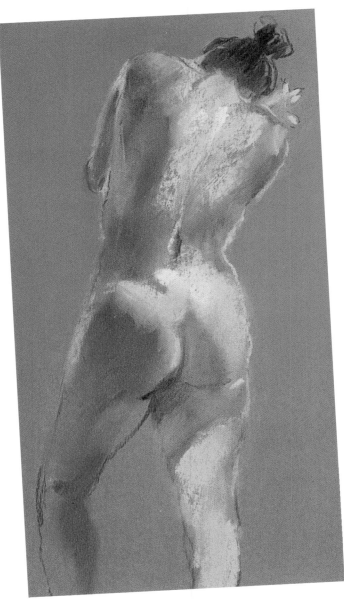

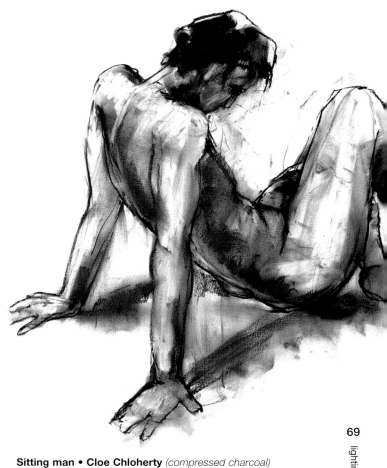

Sitting man • Cloe Chloherty *(compressed charcoal)*
Gradations of rich blacks can be produced with compressed charcoal. Smudging with the finger creates powerful tonal contrasts that work particularly well on white paper.

**Standing in the spotlight •
Maureen Jordan** *(chalk pastel)*
The point of the pastel is used to capture the light, right contour of the figure, while the same pastel used on its side indicates broad planes of light to create a sense of mass and volume.

Nude figure under strong directional lighting effects

Notice how a powerful sense of drama is introduced under the strong directional lighting conditions. Lighting can be so evocative that some artists have used it and the mysterious effects it can create as their subject matter.

class 15

objectives • Creating dramatic shadows with charcoal • Using the eraser to "draw" out highlights

dramatic lighting

Length of pose	1 hour

media
Gray pastel paper
Thick charcoal stick
Kneaded eraser

A spot of light is cast from the left, aimed on the front of the model. The model is posed with the front of the torso turned away from view, allowing the light to pick up the contour of the breast, left hip, and thigh to create a dramatic arc of bright highlight balanced by deep shadow on the back. The model props herself up with her arms from behind, forming a stable triangular structure to counterbalance the graceful arch of the torso.

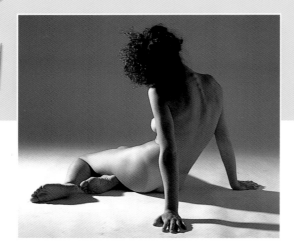

Step 1 Roughly block in the dark tones using the edge of a thick charcoal stick to establish the main curving shape of the pose. Now with the side of your hand, rub the charcoal tone to model the curvaceous shape of the figure, across the plane of the back and in curving sweeps over the left thigh. Use the point of the stick to bring out a few key lines defining the contour of the figure: On the torso, beneath the buttock, and down the arms.

70

creating an impression

TECHNIQUES

blocking in, see page 116

blending, see page 116

highlighting with eraser,
 see page 117

building up tone, see page 117

Step 2 Stand back from your work and focus on the individual limbs. Both arms and the lower legs are cast in shadow, while the light catches the contour in a sharp line. Pick this out using a kneaded eraser, "drawing" with it into the black charcoal to define the highlighted contour. Light reflected from the floor bounces light up onto the back, so use the eraser again here to hatch an area of highlight.

Step 3 Make the deepest shadows darker still using the point of the charcoal stick. With the kneaded eraser, work up the lightest areas on the breast, the left leg, and the left arm. Work over the ground in broad flat strokes, using the side of the charcoal stick, to define the surface of the floor. Describe the curls of hair with the point of the charcoal stick, and, with the eraser, draw out highlights to enliven the texture of the hair.

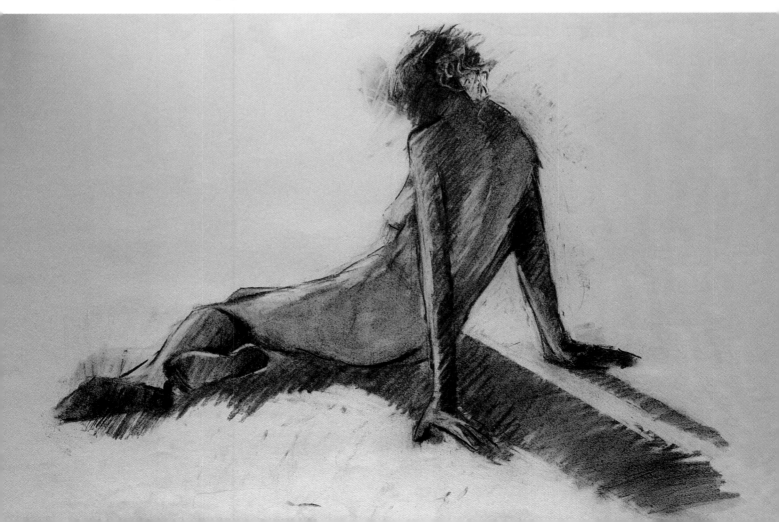

objectives • Learning to observe and interpret areas of light and shade to create a sense of mood • Blocking in chalk pastel

defining mood through light and tone

Length of pose	1 hour 30 minutes

media
Chalk pastel
Charcoal
Kneaded eraser
Colors
 white
 burnt umber
 raw sienna

With eyes closed and hands loosely folded on her lap, the model struck a relaxed, meditative pose. To evoke and emphasize this sense of quiet contemplation, the decision was made to "sculpt" the figure from gentle tones of light and shade. The model was positioned to maximize the way in which the light described the contours of her figure.

72

creating an impression

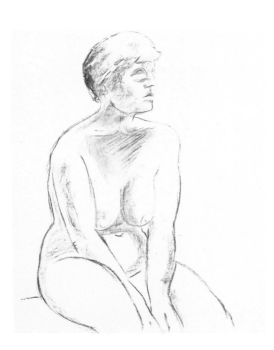

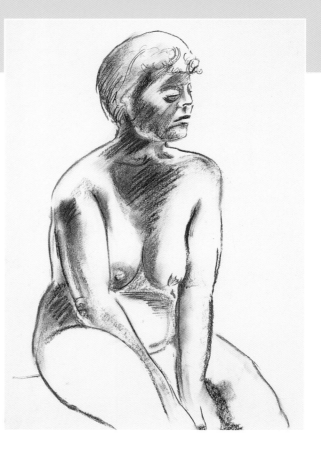

Step 1 Sketch in the contour of the model in charcoal, keeping it as light and fluid as possible—a hard-edged linear feel would detract from the subtler tonal work to follow. This also allows for any adjustments to the proportions or positioning as the drawing develops. Start to lightly add areas of darkest shadow on the model at this stage for future reference.

Step 2 Gradually work up the light and shadow with hatching and gently blend with the finger. Use deep, warm earth colors, such as burnt umber and raw sienna, with a light application of charcoal to define dark areas. The darkest areas of shadow are on the neck and breastbone, and the highlights are on the arms, breasts, and face.

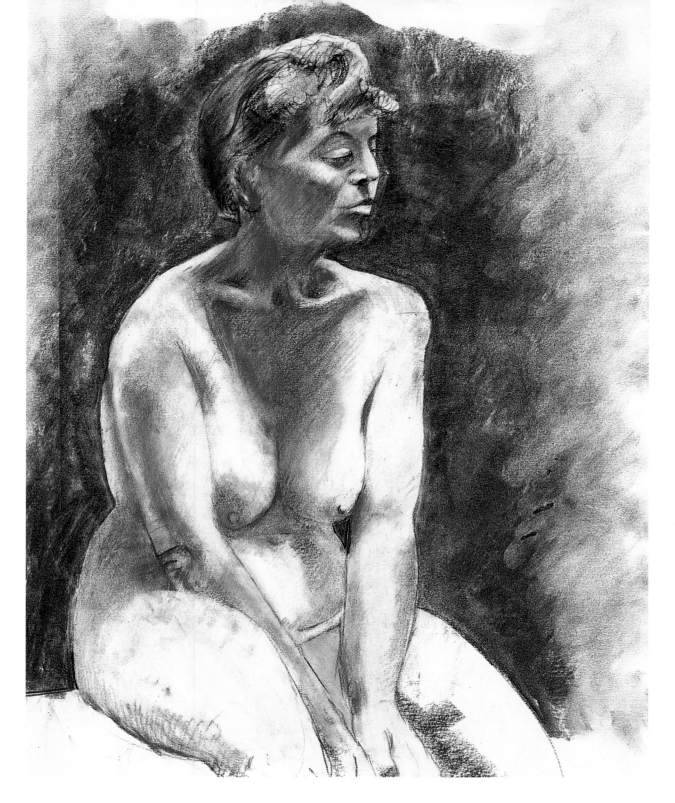

Step 3 Using charcoal, give sharper definition to the facial features and then, with a kneaded eraser fashioned to a point, bring out points of highlight on the brow, nose, lower lip, and chin. Work the eraser gently over areas of highlight that might risk being lost under chalk dust. Finally block in a black background of soft charcoal around the figure to obscure any linear marks left from the initial sketch and to emphasize the sense of the figure emerging from shadow. The finished result is certainly striking. The dark background accentuates the highlights and shadows, strengthening the form and contours of the body and the overall still, contemplative atmosphere.

TECHNIQUES

hatching, see page 114

blocking in, see page 119

highlighting with an eraser,
 see page 117

composition

theory

Think of composition as you might the construction of a stage set, arranging characters and props to create a visually interesting scene.

With two figure studies on a single page, a composition has already been created as a relationship emerges between them. In a figure class, or if you are out sketching, you might not have the luxury of assembling a scene for yourself; you might have to be inventive, using "artistic license" to add in or leave out elements that contribute to the overall effect. Only experimentation will help you decide whether a composition works with the subject. Historically, experiments with compositional ideas formed a vital part of an artist's preparatory work, where all the deliberations remained in the development of the final finished piece. Very often these drawings with all their adjustments have become inspirational pieces in their own right, so never underestimate the value of your experiments!

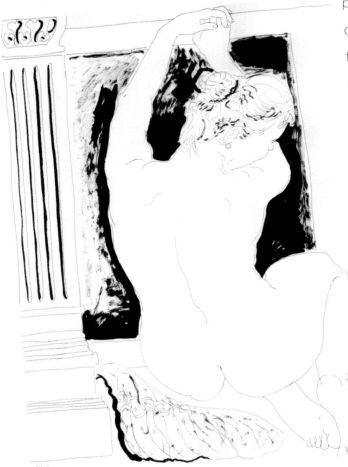

By the fire • David Cottingham (ink, pen, and brush)
The artist uses the fireplace as a device, first framing the figure and then setting off the fine linear work of the torso against the freer brushwork of the shadows contained in a rectangle.

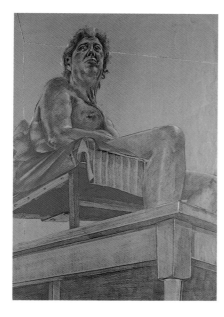

Doris sitting on chair • Lucy Watson
(graphite pencil and chalk pastel)

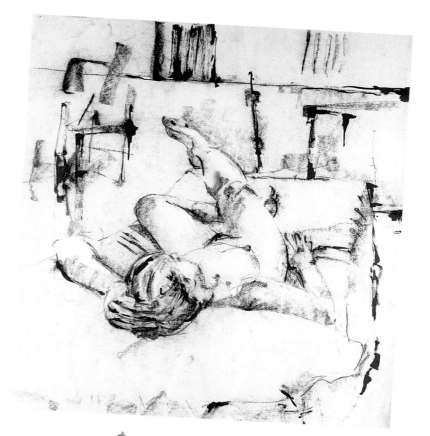

Reclining • Lucy Watson *(ink and charcoal)*
Dramatically foreshortened views of the figure can
make for more interesting compositions, as can
be seen in these two fine examples.

**3 viewpoints on 2 female figures •
Neil Suckling** *(graphite pencil)*
The artist walked around the composition,
stopping to work at three different
viewpoints. Each time a picture emerged
that differed in appearance and suggestion
from the last. In the first picture there is a
meditative mood, created as the standing
figure bows her head and smooth
amorphous shapes are reflected in the
contours of the figures. The second
viewpoint is the least successful: the "back
to back" pose distances any relationship
between the figures. In the third image, the
focus is on the figure in the foreground: Her
profile is nicely set off against the back of
the other model.

VIEWPOINT

This exercise demonstrates the importance of considering various viewpoints before settling down to draw. Many experienced artists use thumbnail sketches and sometimes a viewfinder (see below) to organize their subject matter.

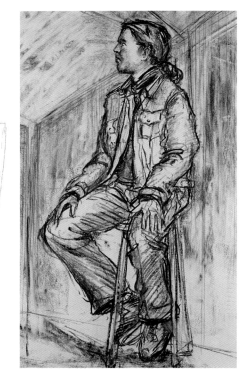

Tom sitting on stool • Lucy Watson
(charcoal and chalk pastel)
Three or four thumbnail sketches won't take long to complete and will give you a good opportunity to test different compositions before deciding which one to take further.

VIEWFINDER

A simple homemade viewfinder can aid the organization of your composition (see page 125). Bring the two L shapes together to home in on one aspect of the scene and make it the focus of attention; or pan out, by pulling the L shapes apart, creating a larger aperture to include more space or other elements.

creating an impression

Sitting quietly • David Cottingham *(ink and acrylic wash)*
The viewfinder can prove particularly useful if you are working with the single figure. It is not always necessary to include the whole figure when drawing from life: the technique of "cropping" the figure can maximize the impact of the work by creating a powerful composition. The viewfinder can help by demonstrating alternative frames in which to place the model before you start to draw, or with the common technique of "cutting down" your work once it is completed.

CROPPING

Remember to use artistic license if required—you don't have to include everything just because it is there. A composition may benefit from removal rather than addition. Some of the most successful compositions are very simple, so try to avoid visual confusion with unnecessary clutter.

Leaning on cushion •
David Cottingham *(ink)*
Cropping the figure on all sides not only gives the image greater impact, but creates a pleasing balance between negative space and form.

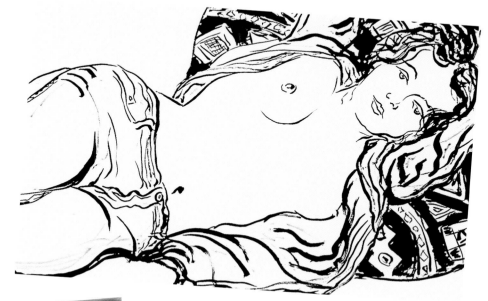

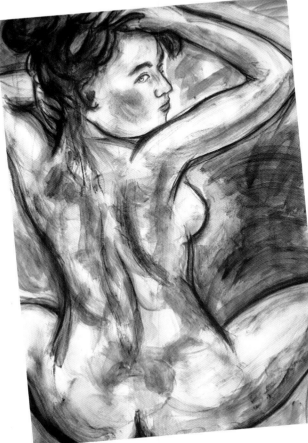

Backview of model • David Cottingham
(chalk pastel and acrylic wash)
By cropping the pose a little at the edges, the figure appears to literally burst out of the page.

class 17

objectives • Working quickly • Making decisions encouraged by experimenting with different viewpoints • Working to the edge of the paper

various viewpoints

Length of pose	1 hour

media
Thick drawing paper
Black drawing ink
Burnt sienna acrylic paint
No. 1 and 2 round brushes

The first stage of this class completes three quick studies before selecting and working up a finished piece in more detail. This exercise encourages decision making, requiring the artist to seek out and work from different viewpoints. The model poses for 60 minutes in all, allowing the artist 15 minutes working time from each of the three different viewpoints and a further 15 minutes to work up the most promising result. Rather than placing the figure near the center of the paper and working outward, make it fill the entire expanse of the page, cropping it at the edges where necessary.

78

creating an impression

Step 1 Use a viewfinder to choose the first pose. Analyze the pose, focusing on strong lines of movement: Across the shoulders, along the spine, thighs, and arms. Use a large brush to describe the contour of the figure in broad strokes, filling the entire paper with the figure. Work quickly, just adding the smallest suggestion of detail on the face, hands, and feet. Dilute your ink with a little water and add more sweeps to suggest areas of tone on the limbs and torso. Repeat the same working process for two more positions. The last viewpoint was thought the most successful, as it appeared to be the least constricted on the paper. So, the model was asked to hold this pose—slightly altered for comfort—for the artist to work up.

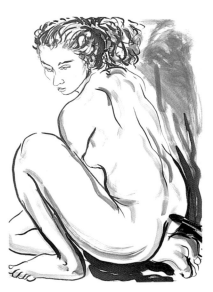

Step 3 Dilute the ink with water and add broad sweeps of tonal wash accentuating again the curves of the initial contour. Now focus on the details, adding some loose squiggling lines to describe the texture of the hair. With a finer brush add tone on the cheekbone, eyelids, and lips.

Step 2 Once the linear outline is complete, work up the image by loosely adding some black tone under the buttock and along the back, to accentuate the shadow and emphasize the contour.

TECHNIQUES

acrylic wash with ink and brush, see page 122

using a viewfinder, see page 125

Step 4 While your ink sketch is drying, mix up a dilute wash of burnt sienna acrylic paint with water. Load your brush with the wash, and dab any excess off on an absorbent tissue before applying. Accentuate the shadows again on the limbs, back, face, and hair; the color brings a warm glow to the figure. Dab up any areas of tone which appear too dark with an absorbent tissue before they have time to dry.

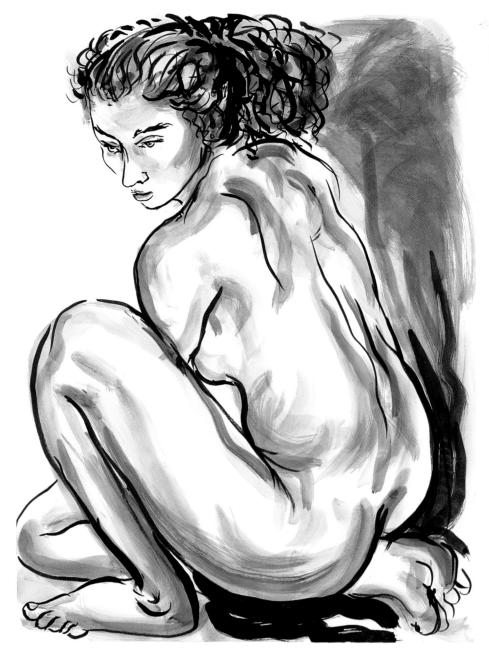

objectives • Creating a striking composition with the single figure
• Blending pastels with the hand (or rag) • Limiting colors for dramatic effect

reclining male

Length of pose	1 hour

media
Drawing paper
Willow charcoal
Compressed charcoal
Chalk pastels
Colors
 yellow ocher
 burnt sienna (light and dark tint)
 cobalt blue (light tint)
 sap green
 black

The artist moved around the pose with the viewfinder, searching for a striking composition to be made with the lone reclining figure. By opening the aperture the figure seemed to be lost in open space, but closing up the aperture and "cropping" the figure within the borders of the viewfinder focused the eye on the dramatic diagonal cut by the torso across the picture plane. Working quickly enhanced the sense of drama, using bold sweeps of movement in a limited range of colors.

80

creating an impression

TECHNIQUES

 sketching, see page 116

 blocking in, see page 116

 blending, see page 119

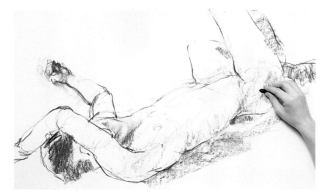

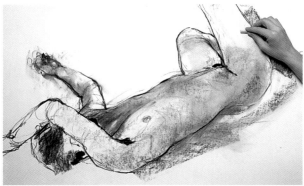

Step 1 Use a thick stick of willow charcoal to sketch in the contour of the figure. Then break off about an inch (2.5 cm) and use this on its side to roughly block in the tonal areas on the figure and on the floor beneath the figure. This will provide a simple tonal piece on which to base your pastel work.

Step 2 Strengthen the contour of the figure using the tip of the willow charcoal. Using small pieces of pastel, begin to block in the flesh tones in burnt sienna (light and dark tint) to describe the line of tone running down the torso, along the left arm, and on the stomach. Add highlighted areas in yellow ocher.

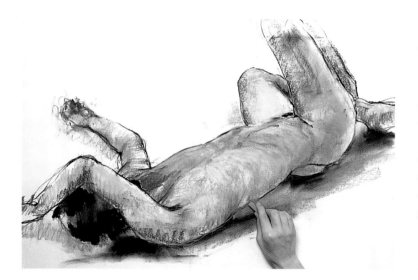

Step 3 Now work these tones into one another with the ball of the hand, or a rag if you prefer. Follow the curves of the body as you go, to "model" the figure: This will create the sense of 3-dimensional form on the flat surface. Work over the shadows by applying sap green pastel. Use the point of the burnt sienna pastel to add details to the extremities. Add the darkest shadows with compressed charcoal, to provide a very rich black on the head and on the floor just beneath the torso and under the left foot.

Step 4 Squint to define the highlighted areas on the figure and accentuate these again, using the yellow ocher pastel on its side to create broad sweeps. Strengthen the shadows in compressed charcoal on the left knee, pubic area, armpit, and under the left hand. Finally, lengthen the shadows under the torso with your hand to "ground" the figure. Add some cobalt blue (light tint) around the outside to complete the lively coloring of the piece.

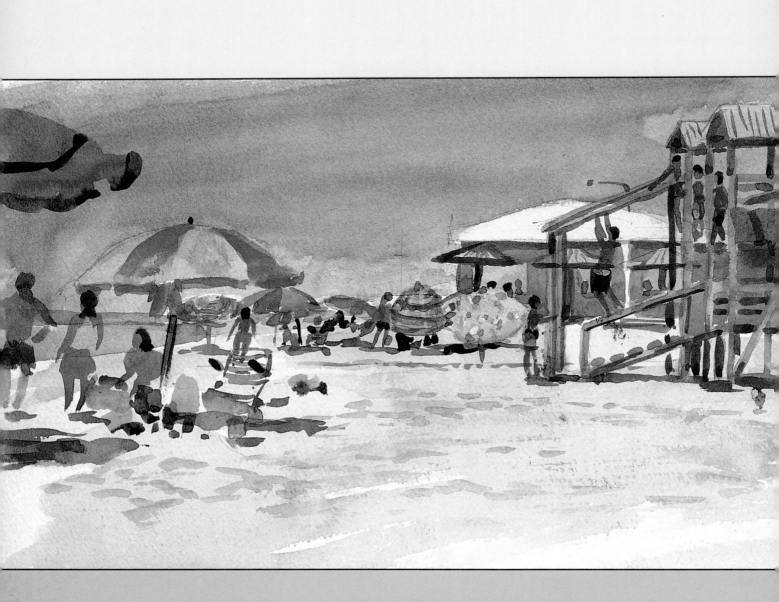

3 Projects

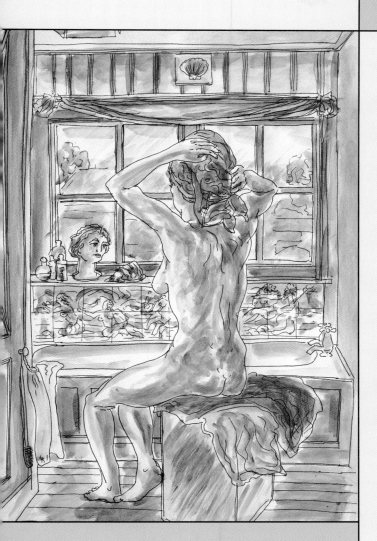

Placing the figure in a "setting" immediately introduces a narrative or story element that can make for a more natural and interesting scene than the figure study alone.

Try putting into practice your knowledge of figure proportions, the effects of foreshortening, light and tone, and color by placing the figure in an environment, fully clothed and going about its daily business.

In the house

Inspiration for a figure composition can easily be found in your own home, using friends and family as models. Simple subjects involving a figure reading a book or watching television provide good starting points as they don't tax the sitter.

A strong sense of mood and place can be evoked if a little time is taken to consider the objective and theme of the work at the beginning. Composing the context is all part of the working process: Think of arranging a stage set, choosing a backdrop, and selecting some props to set the scene; consider the lighting and how it falls on the "stage," and the optimum viewpoint for your "audience."

Making preparatory sketches is one way of organizing your composition and positioning the figure. They will familiarize you with the subject and you can refer to them if the model moves away. See how elements relate to each other: Adding too many can lead to confusion, and bright background colors or unusual objects might steal the show. Most environments have a sense of mood—bright and cheerful, calm and meditative, even melancholic—and your coloring can reflect this by being intense, warm, cool, subtle, or dark. Experiment with colors, use imaginative combinations or turn low-key color to high-key. This takes experience to work successfully, but experiments and even errors are good ways to progress.

The projects chosen for this section make use of a variety of rooms around the house and include small arrangements of suitable props. These can provide material for the artist to work on if the model moves away. A range of media and techniques demonstrate the different impressions that can be achieved.

La Toilette • Henri de Toulouse-Lautrec, 1896, Musée D'Orsay, Paris
The setting and props can often provide nearly as much interest as the figure itself.

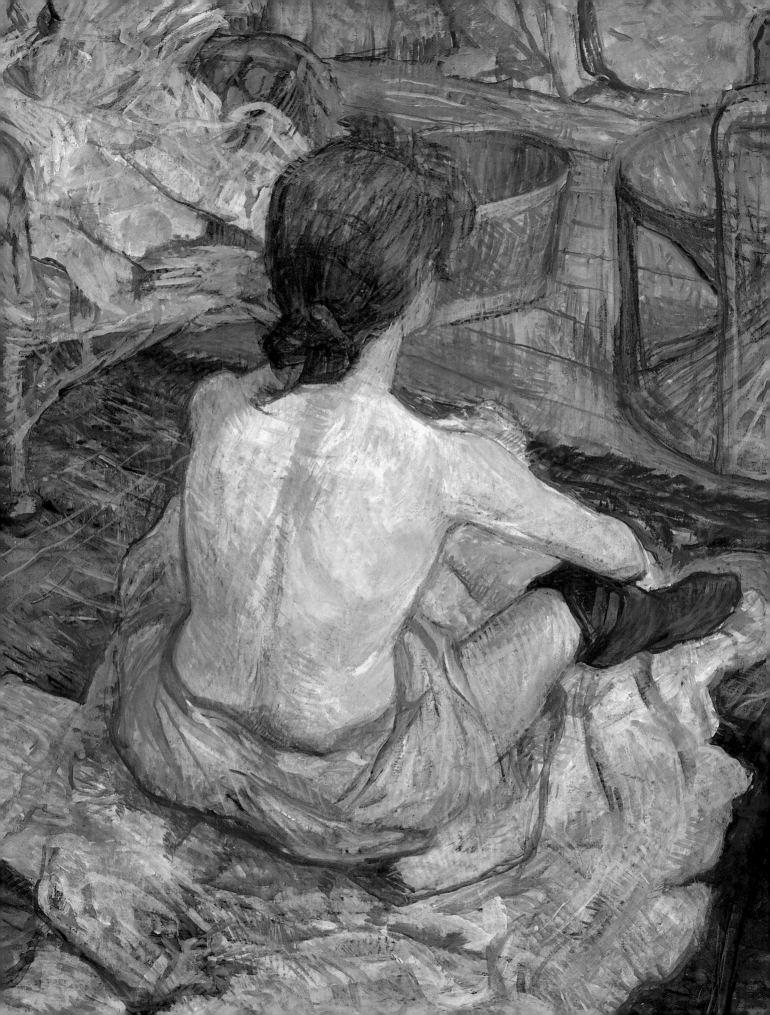

bathroom: seated figure semi draped

Length of pose	1 hour/ time on picture: 3 hours

media
Thick drawing paper
Ink pen
Black ink
Acrylic wash
Acrylic paint colors
 cobalt blue
 raw sienna
 raw umber
 Indian red

86

projects

The device of looking through a doorway into another room not only adds a structure in which to frame the pose but also leads the eye into the scene, playing on the theme of "artist as voyeur." This is inspired by the wonderful suite of paintings by Pierre Bonnard, who tirelessly painted his wife taking her daily bath glimpsed in reflections and through doorways. The window forms a horizontal rectangle that takes the eye beyond the figure to follow her gaze to the outside, thus "opening up the box." The small bust of Venus chosen to be a prop on the window sill not only introduces a narrative element to the work but also provides a face as a focal point.

The drawing starts in pen on a heavyweight drawing paper that will withstand the addition of light washes. The objective is to capture the body shape presented by this pose in just a few flowing lines, keeping the subject fluid and delicate. Transparent washes of cobalt blue, with raw sienna and umber are added. The fluidity of technique and contrast of warm and cool tones ideally suit this setting.

TECHNIQUES
 ink drawing, see page 121
 acrylic wash on ink, see page 122

Step 1 Draw the contour of the seated figure in an almost smooth continuous line.

Step 2 Draw in the window next: This establishes the first structural element in the composition as well as taking the eye out beyond the bathroom setting.

Step 3 Ink in the other main structures: The verticals of the open door and paneling on the wall, and the horizontal flooring boards and bath. These give an enclosed box-like impression, but the landscape beyond the window opens the room up by focusing the eye outside. Concentrate on the small details that make the room unique: The frieze on the bath tiles, the ornaments on the window sill, the lampshade—all make the scene interesting and provide a sense of this personal space.

Step 4 This scene is full of strong vertical and horizontal lines, so to prevent it looking too much like an exercise in perspective, go over the main structural lines in the door and the wall paneling more roughly. To "loosen" the work still further, add cool washes of cobalt blue to describe the soft shadows in this naturally lit scene.

Step 5 Once the blue tone has been worked up all over the piece, add warm tones using washes of raw sienna and raw umber with a touch of Indian red. These earth colors contrast with the cool blue to warm up the figure and the setting. Add these in light washes to give the dappled light effect. Touch up areas on the details. Working on the textures and tonal areas helps to soften the structural element of the piece. Be careful not to overwork the painting; retaining areas of untouched white paper keeps the work lively and fresh.

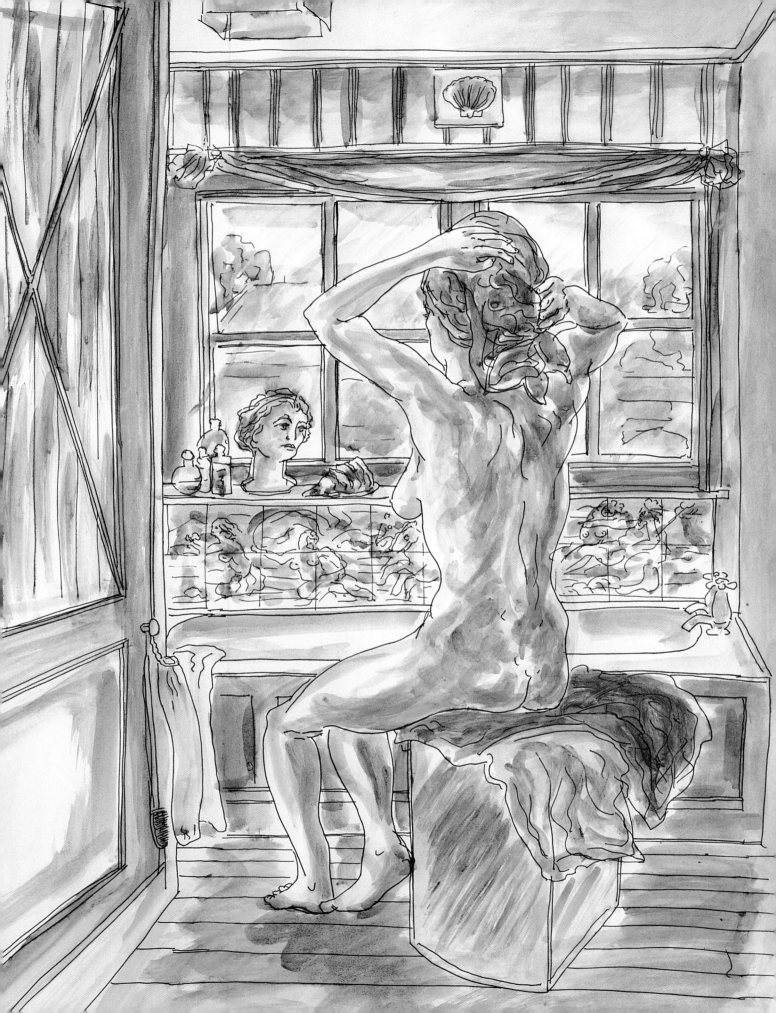

objectives • Imaginative color • Use of deep toned paper • Glowing effects

study: seated figure

Length of pose	1 hour/ time on picture: 2 hours

media
Deep-toned pastel paper
Chalk pastel
Colors
 vermilion red
 white
 crimson lake
 mauve
 cobalt blue
 yellow ocher
 burnt sienna
 veridian green
 olive green
 light gray

This pose was casually arranged: A young man reading a newspaper in the study. His striking vermilion red and white striped shirt inspired the artist to depart from reality and use a riot of bold and imaginative coloring effects on purple paper to give an almost surreal effect to the work. Suitable objects were selected as props: An old-fashioned fan was placed on the desk as its metal blades presented an interesting structure and reflected bright highlights, a glass vase of vivid red flowers brought a show of color to a dull corner, and the window was opened to intensify the bright lighting cast over the desk and the figure.

90

projects

TECHNIQUES
 blending chalk pastel, see page 119

Step 1 Make a sketchy outline of the figure and the surrounding composition. Once everything is in place you can assess if any repositioning is needed. In this case the fan was moved because its circular shape confused the head outline.

Step 2 The focus of this work is bright pure color, so immediately start blocking in, using vermilion red for highlighted creases in his shirt and cobalt blue for his jeans. Don't worry if these look overpowering at the beginning—they can easily be knocked back later. The figure was tackled first so that the model could then take a break, but the subtler areas of shading of the face were left until another stage.

DETAIL: COLOR
By adding soft blends of mauve to the shirt, the figure is successfully linked to the background.

Step 3 Block in the interior with intense color effects using crimson lake with blends of mauve for the wall, which reflects onto the open newspaper, and for the stripes of the shirt, while a bright orange forms the base color for the curtain. They appear bright and clashing at this first layer of working, but will be toned down later. Use burnt sienna and yellow ocher for the furniture and floor.

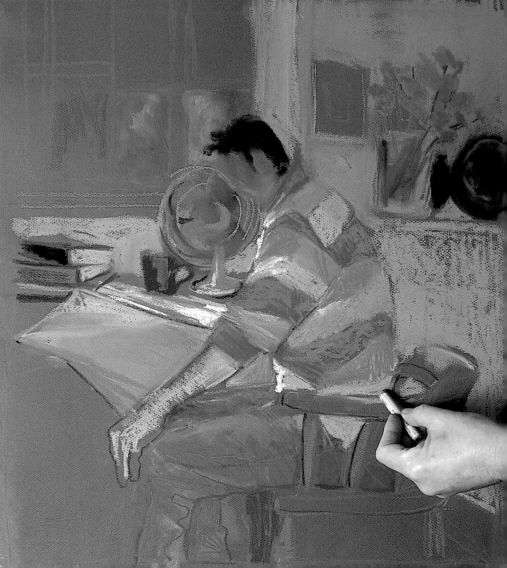

Step 4 Add the suggestion of greenery in bright veridian green and olive green beyond the window. Work up bright highlights on the fan in light gray and white, then add white highlights to the other reflective surfaces such as the handles on the desk drawers and the glass vase of red flowers.

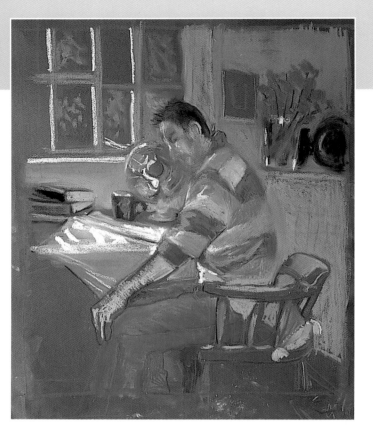

Step 5 "Work down" now by smudging the colors with the finger, which quickly takes away their intensity. Work over the entire drawing in this way to bring an overall sense of unity.

Step 6 "Work up" bright accents where the subject is touched by sunlight, on the face, edge of the desk and the books, and along the vertical struts of the window frame.

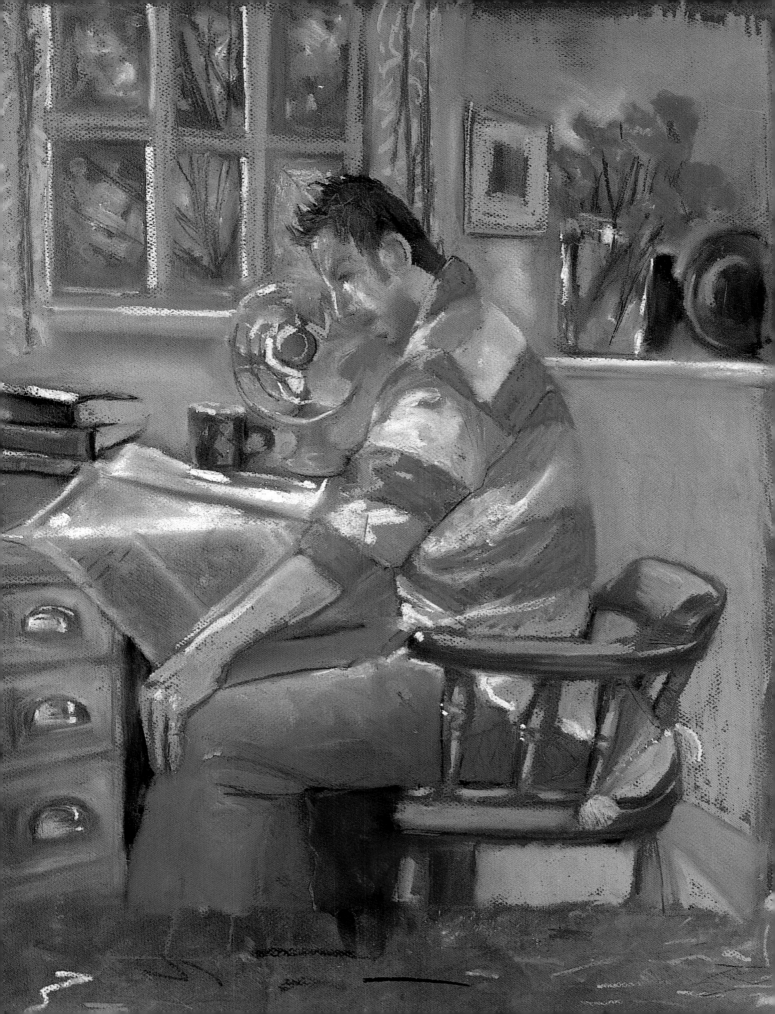

kitchen: mother baking

Length of pose	1 hour/ time on picture: 3 hours

media
Cartridge paper
2B graphite pencil
4B graphite pencil
Color pencils
 yellow
 blue
 red
 light brown

This kitchen scene was chanced upon and a sketch made while the model worked. She agreed to hold the pose for 15 minutes while details were added, and to change into a blue stripy apron that picked up the pattern of the tablecloth and kept the color spectrum within a range of muted blues and yellows. Ingredients were grouped on the table for the artist to work on when the figure moved away. An exercise like this challenges the artist to record the figure quickly and retain a visual memory of the scene. Take a note of the main direction of lighting: Even if the model moves, shadows will be cast in the same direction. Limit your selection of colors and work up tones by hatching, cross hatching, or applying firmer pressure. Focus on the important elements at the beginning: Record the facial features and hands and feet (if they appear). Shadow shapes can be lightly sketched in to describe folds on clothes for working up into dark areas of tone later.

94

projects

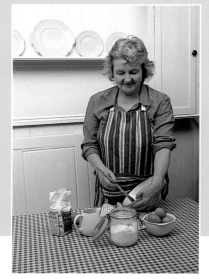

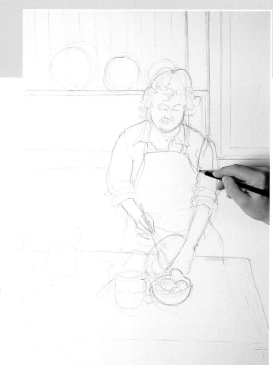

Step 1 Make a light pencil drawing of the figure in graphite pencil, then sketch in the surrounding room structure, using a straight edge if necessary to align the shelf and table top. The model now moves away so focus attention on the main shapes of objects on the shelf behind. When everything has been roughly drawn in, items can still be rearranged to improve the composition.

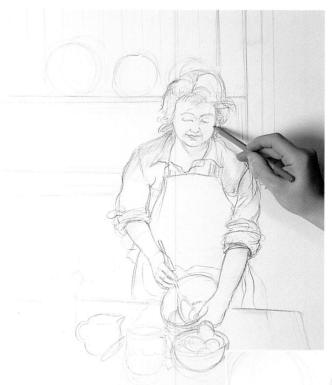

Step 2 The figure—the only moving object in the composition—returns to the scene and is asked to hold the pose for just 15 minutes. Concentrate on drawing in the hands and face, but keep them simple as they can be worked up later.

<small>TECHNIQUES</small>

sketching with a pencil, see page 114

hatching, see page 114

cross hatching, see page 114

building up tone, see page 118

Step 3 Work up the flesh tones over the face and arms with soft hatching in pale brown. Then, using a blue pencil, sketch in the main shapes made by the folds in the blouse and begin hatching these in to describe the darkest areas of shadow. The stripes are added to the apron as brisk short horizontal lines. A 2B graphite pencil is used to describe the silver gray hair in fine sweeps.

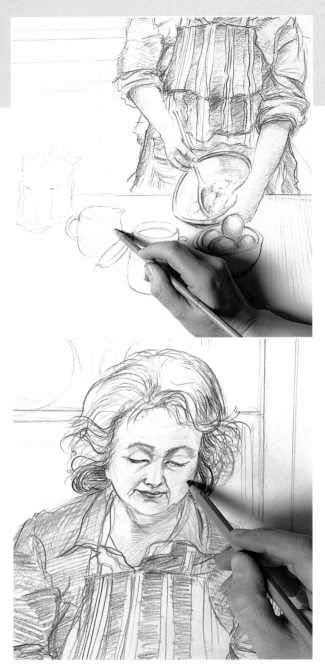

Step 4 The model breaks from the pose again, so work up the areas on the utensils and ingredients. A variety of textures are presented here, from the smooth forms of the eggs and china to the crumpled bag of flour. Use curving strokes of pale brown to describe the rounded form of the eggs, leaving the highlight on each as a small circle of untouched paper. Graphite pencil is used to describe the reflection on the shiny inside of the bowl and the glass jar of sugar. Use the yellow pencil in smooth strokes to describe the rounded form of the milk jug, and in rough cross hatching to describe the paper of the flour bag.

Step 5 Intensify the blue shading on the blouse and apron with cross hatching. Work up the flesh tones in a similar way, gradually building up the intensity of tone over the face and arms. Add just a little red to the face to warm it, and also to the lips. Add a touch of red to the hands too as the extremities appear a little rosier than the limbs.

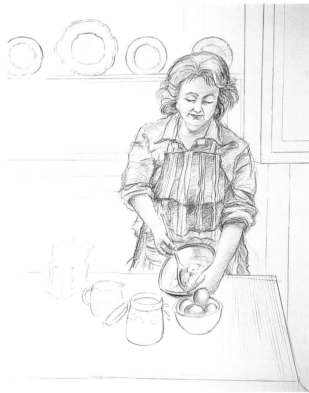

Step 6 Texture, pattern, and shadow can be added over a longer period of time. Hatch in some blue shadow on the shelving to give the appearance of soft natural lighting effects and shade the plates in yellow, fading out toward the edge of the drawing to keep the main focus of attention on the figure. The checkered tablecloth describes the perspective of the table top and gives depth to the composition. Draw the lines of the checkered pattern and then work over roughly and quickly to break up the "technical" appearance and harmonize with the overall soft finish.

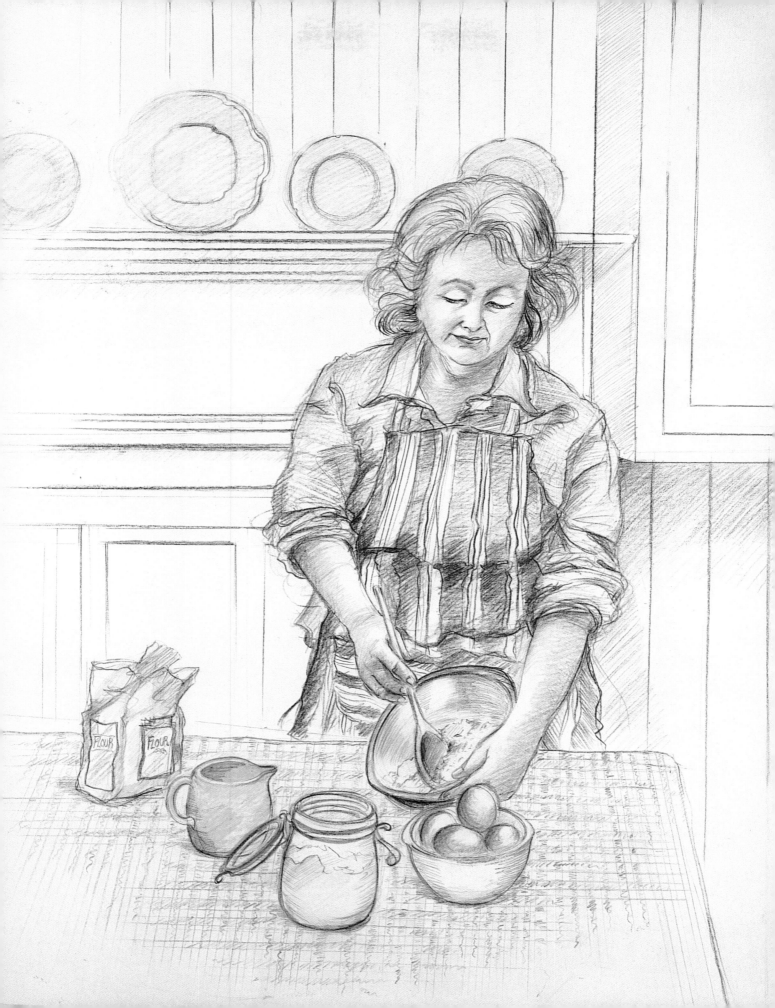

bedroom: brushing hair in mirror

| Length of pose | 1 hour/ time on picture: 3 hours |

media
Watercolor paper
HB graphite pencil
Watercolor paint
Colors
 cobalt blue
 Indian yellow
 cadmium red
 Russian green
 cadmium yellow
 mauve
 light red
 Prussian blue
 burnt umber
 yellow ocher
 black
 alizarin crimson
Brushes
 no. 1 flat
 no. 2 round
 no. 6 round
 no. 20 round

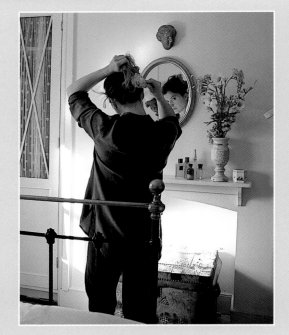

Sunlight floods into the room, creating a steep shaft of dazzling light that is caught in the open fireplace, reflects from the walls, and illuminates the face in the mirror from beneath. The artist makes this dramatic effect the subject of her work. The warm yellow light is balanced with cool mauve shadows: Not only are these complementary colors but together they perfectly capture the freshness of this morning scene. The colors are worked wet on wet and the objects in the room are treated in a looser style to keep the main attention focused on the central figure, and to enhance the fluidity of the natural lighting.

Step 1 Lightly sketch in the contour of the figure and main elements of the composition to provide a guide for placing the first layer of dilute watercolor.

Techniques

 sketching with a pencil, see page 114

 laying down watercolor wash, see page 123

 working wet on wet, see page 122

 working wet on dry, see page 123

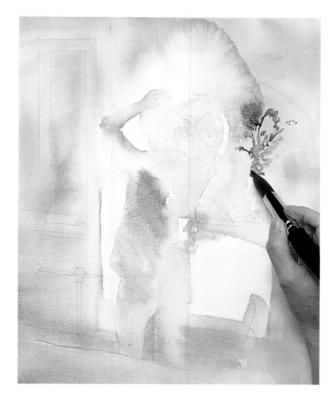

Step 2 Wash plain water over the entire drawing and dab it dry with a clean cloth to prepare to work wet on wet. Make a dilute mix of mauve and apply with a flat brush to create the shadow areas in the composition. Then clean the brush and add some Indian yellow to the areas touched by light. Leave the area of most intense sunlight, down the left side of the figure and at the bottom right side of back, free from wash: The brilliance of the untouched paper will provide your brightest highlights later.

Let the colors bleed into one another producing a fluid effect. While the work is still wet add a touch of Russian green to the shirt allowing it to steep this area, then add a little detail to the greenery in the vase of flowers.

Step 3 Work in more pure washes of color wet on wet: Apply cadmium red to the skin tones on the arms and a little in the mirror where the reflection of the face is visible. Fill in the outline of the figure and define the bottles and vase on the mantelpiece with a dilute wash of cobalt blue. Work up darker accents: Apply more cadmium red to the flowers, and add another mauve wash to the wardrobe to define the drapes though the doors. Finally mix burnt umber and Prussian blue and a touch of alizarin crimson for a rich dark blend. Apply a diluted mix of this blend on the left side of the shirt where sunlight catches the folds in the fabric.

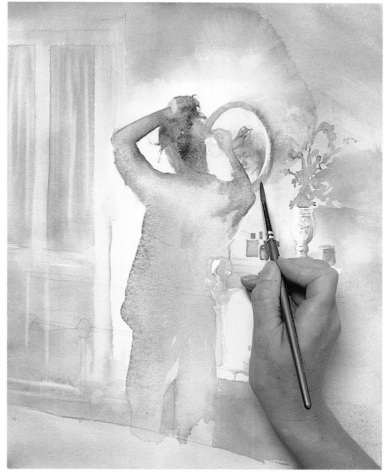

TIP

Rest your working hand on a piece of clean paper to prevent smudging your watercolor as the work progresses.

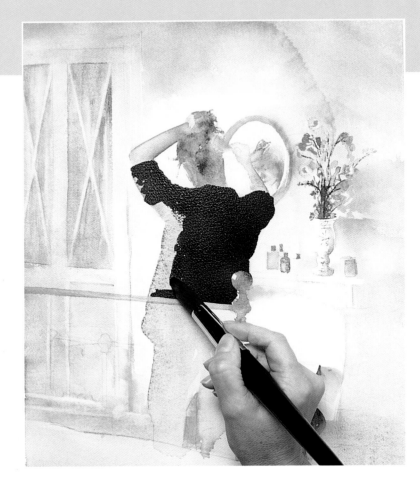

Step 4 Use the dark blend from Step 4 to block in the shirt. Work up the skin tones on the arms in a light red, with dilute washes of mauve to define tone on the right arm. Add the details to the face: A little light red on the cheeks and lips, and the same dark blend from Step 4 to touch in the eye, eyebrow, and—just a tiny light touch—the nostril. Define the shape of the head by blocking in the dark hair color in burnt umber, then use yellow ocher to describe the rest of the hair, pulled up in a bunch where it catches the light. Continue working with the yellow ocher to enhance the long shadows cast on the wall by the flower arrangement, taking them off the edge of the page.

Step 5 Now work in accents using the dark blend. Loosely sketch in some shadows at the bottom of the wooden chest. Next define the second bar of the bed using the brush almost dry against a ruler to make a broken line. Dilute the blend to flood in the area on the bedcovers and then lift out some soft highlights. Using plain water on a clean brush, gently stroke the soft pleats of the shirt that catch the light until the pigment is gently teased off and then dab with a clean, absorbent tissue. Use the same method on the two bedposts behind the figure. This will highlight the bed against the dark background of the figure, bringing it forward to establish a sense of depth.

TIP

> Black can create a flat, deadening effect in watercolor, so work up a mixture of burnt umber, alizarin crimson, and Prussian blue to provide a dark color which will be much richer than black.

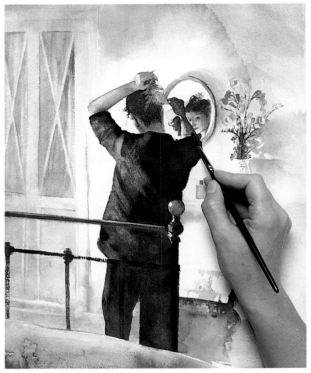

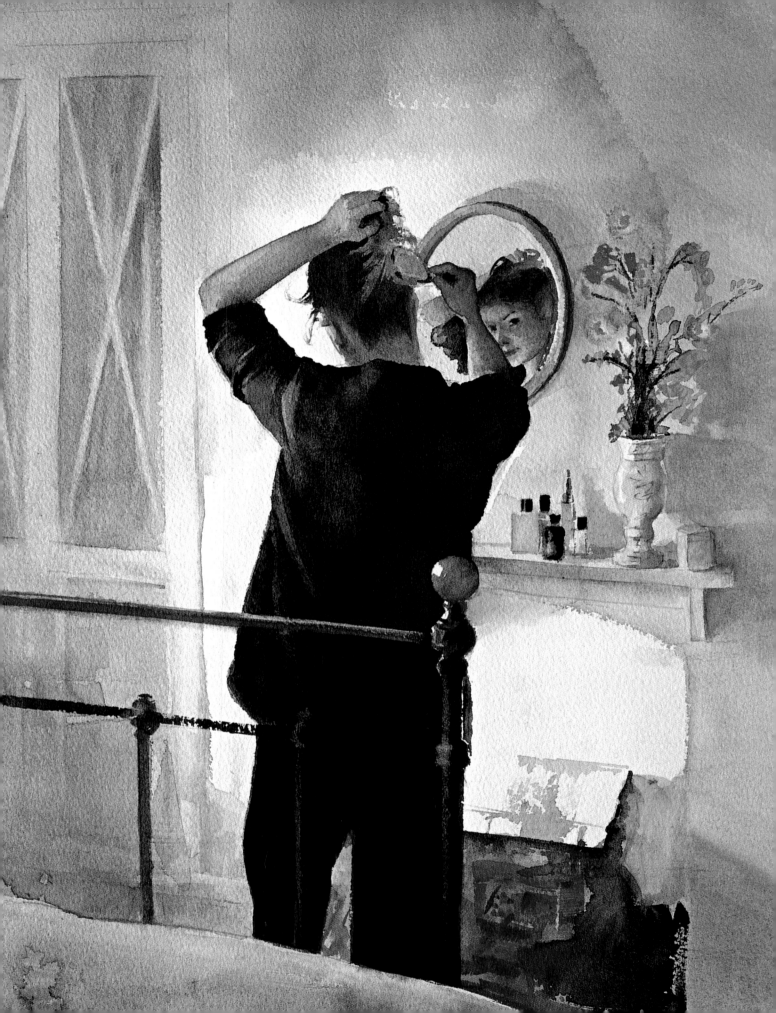

objectives • Working by artificial light • Working in layers of transparent washes • Focusing on details

sitting room: evening reading

Length of pose	2 hours/ time on picture: 4 hours

media
Watercolor paper
Watercolor paint
HB graphite pencil
Colors:
 cobalt blue
 neutral tint
 burnt umber
 raw sienna
 yellow ocher
 rose madder
 veridian green
Brushes
 no. 1 flat
 no. 2 round
 no. 6 round

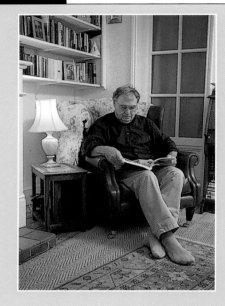

This composition is set up in a corner of the sitting room. The table, lamp, window, and rug provide a structure to position the figure in the chair. The dark window behind suggests an evening setting, but in fact a drape was hung behind the window to convey the effect of an evening's peaceful reading by lamplight. With this in mind a relaxed pose was struck: Feet crossed and an open book on the lap. Soft tones of blue, umber, and ocher reflect the low-key atmosphere, applied in transparent layers to convey the muted overall lighting.

Step 1 Make a light pencil sketch of the figure and the immediate vicinity, keeping it loose so any alterations to the composition and figure positioning can be made at an early stage. The sketch will form the "scaffolding" to the work, delineating the areas for color washes to follow.

> TIP
>
> Applying white paint to a watercolor painting can have a chalky and dulling effect. The best highlights will always be areas of untouched white paper. Bear this in mind when you are blocking in color at the beginning of your work and use masking fluid if necessary to protect these areas until the end (see page 123).

Step 2 Start with very light washes, putting down the darkest areas of the figure and background first in cobalt blue and burnt umber to set the low-key tone. By blocking in the entire composition including the figure at the beginning an overall cohesiveness is established.

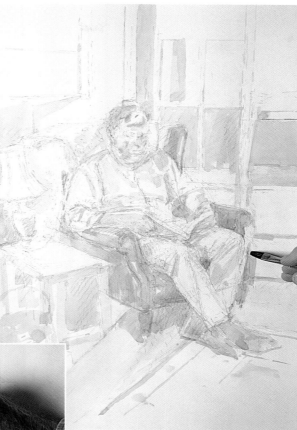

Step 3 Once the first washes have dried, build up areas of darker tone by laying on further washes with the paint mixed a shade or two darker. You might find it useful to test on a scrap of paper before applying directly to your work.

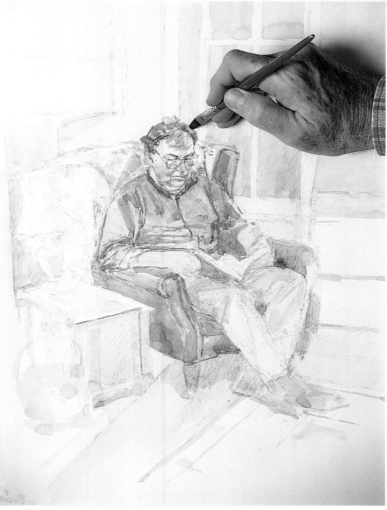

TECHNIQUES

sketching with a pencil, see page 114

laying down watercolor washes, see page 123

working wet on dry, see page 123

Step 4 Continue working in layers, but leave the lightest areas of the setup untouched: The white ground of the paper provides the liveliest and freshest highlights of the work. Work up the deepest color tones evenly over the composition. Define details on the face with a little rose madder to bring warmth. Then add folds in the shirt with a mix of neutral tint and cobalt blue, and dark shadows to the leatherwork on the chair in raw sienna. Apply these details carefully with a very fine brush, dried a little on absorbent tissue before applying to the painting, to prevent them being spoiled by an overload of paint.

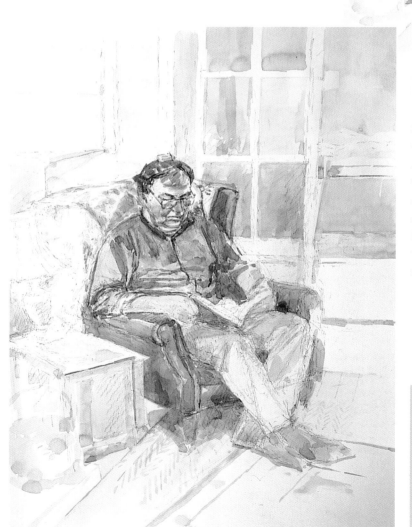

Step 5 Roughly apply the coarse texture of the matting in diagonal strokes of yellow ocher. Add the suggestion of pattern to the rug under the feet in rose madder and veridian green, along with some books on the shelves, and a small coal scuttle in neutral tint on the hearth. Keep the treatment of these details light and "washy" so they don't intrude to confuse the main focus of the work—the figure in the chair.

TIP

Ensure you view your work in daylight conditions as working by artificial light changes the appearance of colors dramatically.

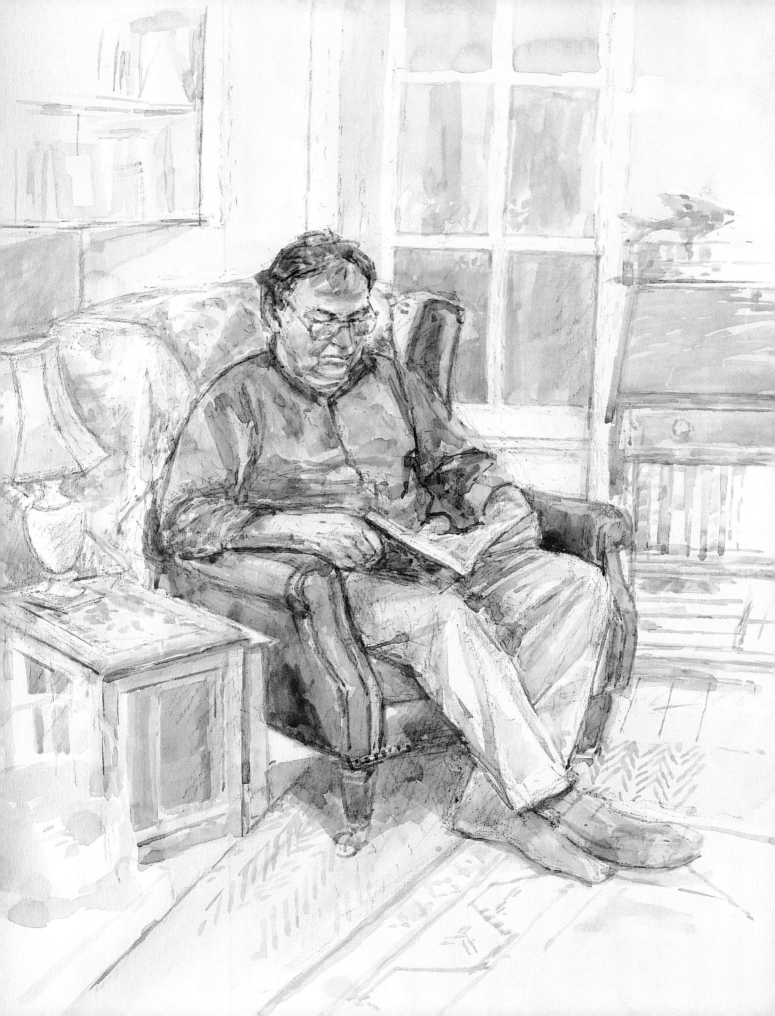

Out and about

A small sketchbook and pencil in your pocket or bag is a good idea for sketching people going about their daily activities. Find a place to sit and watch the world go by: A café, park, beach, even a seat in a busy mall. Try not to let the subjects become aware of your sketchbook—it could make them self-conscious and destroy the naturalness of their movements.

You will have to work quickly and decisively, so forget the eraser—but don't think of this as a drawback. The need to focus on the essentials often gives lively spontaneity to a drawing. Toulouse-Lautrec did this superbly when he drew the dancers in the Moulin Rouge music hall in Paris. With a few lines that seem as swift as the dancers' movements, he could convey their energy and vitality.

Use your camera to help you capture these momentary glimpses of daily life if you want to use your sketches later as the basis of a picture, or as an aide-memoire. But don't let the camera become a substitute for that all-important sketch done on the spot. However hasty or clumsy it is, it will have that unique spontaneity that comes of working from life.

Some points to consider: Decide what your focal point is to be. Do you want the figure to take center stage? Or maybe the environment is more important and the figure incidental to it—this is often the case when working outdoors, when a small-scale figure is set against towering architecture or large expanses of landscape. If you are working by natural light, it will change as time progresses. A brightly lit scene can evaporate in seconds if it clouds over, so make sure you sketch in your highlights and shadows first.

project 6

objectives • Recording information quickly • Capturing
vivid colors • Portraying light and shade • Unifying components

out and about: children at play

Length of pose	30 minutes each

media
Drawing paper
Chalk pastel
Compressed charcoal
Colors
 cobalt blue (light tint)
 French ultramarine
 violet
 bright red
 rose madder (light tint)
 cadmium red (light tint)
 burnt umber
 madder brown
 emerald green
 sap green
 lemon yellow
 warm gray

Children can prove challenging subjects as they are constantly on the move, but provide good practice in producing quick and lively sketches capturing their charm and inexorable energy.

This series by Mark Topham filled several sketchbook pages while sitting on a bench in the local park. Quick linear sketches were made to begin with while the children played with a toy, or on a swing where the repetitive movement gave time to record just enough information to work up the piece later. A subject like this is good training as you focus on a few key areas, summarizing the essence of a scene in "visual shorthand." Some color notations were made on the spot, but in a subject such as this you can be playful and make up color and pattern to enhance the spirit of liveliness.

108

projects

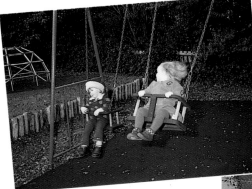

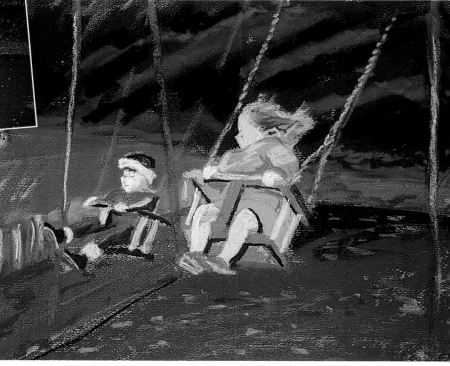

Children on swings *(chalk pastel)*
One child was drawn at a time: The artist drew in the first child swinging, then finished the structure of the frame and a little background before the second child came to play. The artist worked on a mid-toned paper, allowing flecks of it to show through and enliven the composition.

Baby and green car *(chalk pastel)*
The artist blocked in the areas of vibrant colors, blending for a smooth effect. The face is very simply described in two shades of pink, a darker on the face, which is cast in shadow, and a lighter to capture the sunlight hitting the head from the side and behind. The effect of bright winter sun is further enhanced by the streaks of long blue shadow in the background.

TECHNIQUES
shading, see page 118
blending, see page 119

Child pushing buggy *(chalk pastel)*
Bright accents of light are roughly laid down on the hair, folds on the jacket, and back of the right leg, balanced by dark accents of shadows on the opposite side to describe bright sunlight cast from behind. A dark bush was added to the background to push forward the coloring of the little figure.

objectives • Artist as voyeur • Composition and structure: "Telling a story"
• Capturing brilliant lighting effects

out and about: on the beach

Length of pose	1 hour each

media
Watercolor paper
Drawing paper
2B pencil
Range of color pencils
Range of watercolor paints
Range of watercolor brushes

In summer, beaches are excellent places to find source material, providing a range of colorful bathing costumes, towels, umbrellas, and wind breaks under brilliant lighting effects, as well as a mixture of dynamic activity (usually around children) and reclining, sunbathing poses. There are storytelling elements for your work as well: Fishing in rock pools, beachcombing, or paddling, to name just a few.

110

projects

Fishing • Ray Mutimer

(graphite pencil and watercolor)
By quickly sketching the simple outlines of the children at play, the artist captures the mood of activity and excitement. He is then able to add the colors at a later stage, working the watercolors wet on wet and wet on dry.

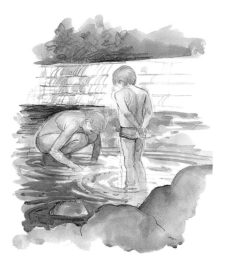

Rockpool • Ray Mutimer

(graphite pencil and watercolor)
An initial pencil sketch gives structure to the scene. Delicate watercolor washes are then added to describe the overhead sunlight cast on the figures and rippling water.

TECHNIQUES

sketching with a pencil, see page 114

hatching, see page 114

wet on wet, see page122

wet on dry, see page 123

masking, see page 123

Studies of bathers • Charlotte Stewart *(color pencil)*

Hatching color pencil quickly and effectively captures the color and shadows of the small figure groups. Leaving areas of the white paper showing through creates a bright sunlight effect. Each sketch took about 10 minutes and put together they create a lively beach scene.

Beach scene • Mark Topham *(watercolor)*

Watercolor washes were used to build up this busy scene. The figures appear to be incidental, yet without them it would be quite desolate. However small a figure might seem, the viewer will generally relate to it above all else in any piece of work.

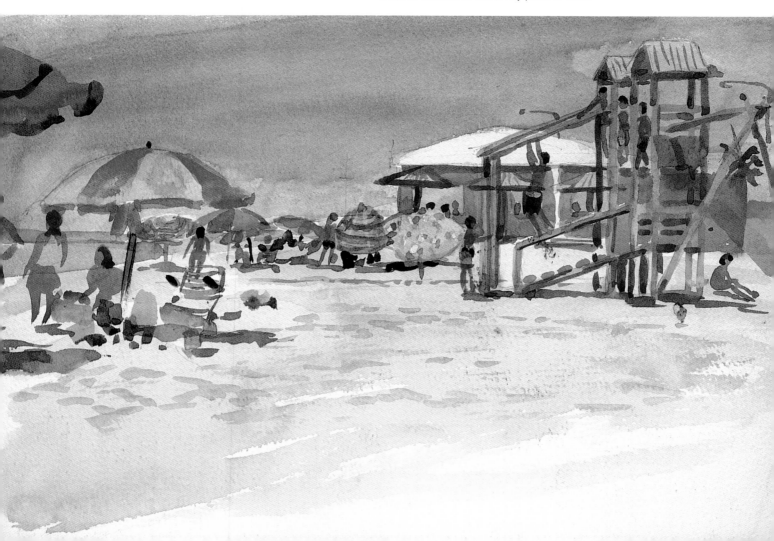

out and about: travel

Length of pose.	1 hour each

media
Watercolor paper
Range of watercolor brushes
Range of watercolor paints

The opportunity to capture something entirely new and memorable often presents itself when traveling in foreign countries. A small kit of art materials is an essential part of any artist's luggage. Different lighting conditions, cultures, customs, dress, atmosphere, or just daily life are absorbed and more firmly imprinted in the memory through sketching than by taking a photograph, enabling you to recall the minute detail of journeys, peoples, and places as the sketchbook becomes a fascinating travel log, as illustrated in these wonderful, vibrant works by Julia Cassells.

112

projects

Camels *(watercolor)*
These charming watercolor sketches illustrate very well how the local, sometimes pesky, mode of transport entertained the artist. A brush drawing technique is used to capture the linear forms. Areas of white paper are left untouched—these add a great sense of directional sunlight to the composition.

Urn *(watercolor)*
This is a quick and simple picture of a boy drawing water, but it is very effective: A real sense of mood pervades the piece.

TECHNIQUES

wet on wet, see page 122
wet on dry, see page 123

Figure on steps *(watercolor)*

The presence of the figure brings energy to the work. Very simply depicted, the suggestion of form is enough to create a bright, lively contrast to the somber building.

Afternoon sun *(watercolor)*

The heat of the sun is beautifully captured in the bright highlights and pale blue shades of the man sheltering under the umbrella.

Fishermen *(watercolor)*

This watercolor sketch captures the immediacy and atmosphere of young fishermen at work on a bright summer's day.

Two women *(watercolor)*

The artist is given plenty of opportunity to exploit her color box as the dress and costumes bring an abundance of bright colors and inject a feeling of life into the work.

◀ GRAPHITE PENCIL

The graphite pencil is an ideal sketching medium, not only easy to carry around with a pocket sketchbook but versatile to use. For general purposes there is the middle of the range HB pencil, but grades range from 8B, the darkest and softest, up to 8H, the lightest and hardest. Most artists keep just a small selection including a mixture of both hard and soft—HB, 2H, B, 2B, and 6B would make an ideal starting selection, which could then be tailored to your preferences.

◀ Pressure How much pressure you apply on the pencil will affect the density of mark you make, particularly within the softer B range of pencil.

◀ HATCHING AND CROSS HATCHING

Hatching is the term used to describe short parallel lines drawn close together at the same angle. Cross hatching is two sets of parallel lines, one on top of the other, with the second set at an angle to the first.

▶ SHADING

Holding a soft pencil at 45 degrees, fill in the area of shading with gentle strokes sweeping back and forth. Shading round the form of the figure will emphasize the sense of volume, as you can see on the forehead and sleeve of this figure.

◄ GRAPHITE STICK

These are short blunt sticks of compressed graphite and also come in a range of grades. They are ideal for blocking in large tonal areas by using them on their side, but can be sharpened to a point with a razor blade to produce thick expressive lines.

► CHARCOAL PENCIL

Similar in appearance to a graphite pencil, a charcoal pencil is a slim stick of compressed charcoal sealed in a wooden casing. Being softer than graphite, it produces a thicker, velvety line making this a perfect drawing medium and for making preliminary sketches and adding fine detail to finished pieces.

◄ **Tonal work** Carbon pencil can be used to produce a great subtlety of tonal variation by applying a careful balance of light and firm pressure.

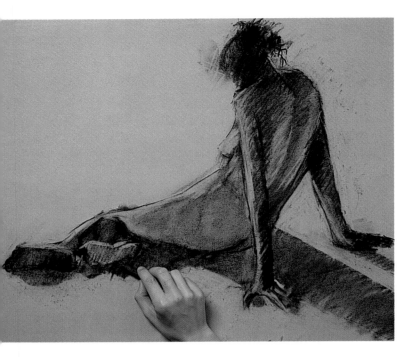

◀ CHARCOAL

Charcoal can be laid down, blended, and erased with ease, making this an excellent sketching medium. It comes in thin, medium, and thick sticks and is commonly used for warm-up short exercises and preliminary sketching. Be aware that it smudges easily and can darken subsequent layers of over work.

media and technique directory

▲ **Thin willow charcoal stick** Expressive line work can be produced with thin willow charcoal sticks.

▲ **Thick charcoal stick** Used on their side, thick charcoal sticks can be used to "block in" large areas of tone quickly.

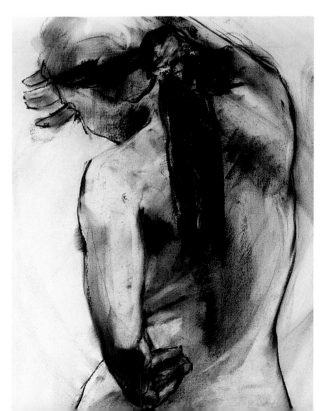

▶ **Compressed charcoal** This is harder and denser than willow charcoal so is an ideal medium for very bold, heavy black marks.

▲ **Tone** Delicate gradations of tone can be worked out of the charcoal tone by smudging it with the finger or a soft rag.

▶ **Using an eraser to pick out highlights** Bright highlights can be worked out of areas of tone with the eraser. Fine "points" of highlight can be "lifted out" of areas of tone with a soft kneaded eraser shaped into a point.

▲ **White conte pencil for highlighting** Sharpened to a delicate point, the white conte pencil is used to add finely hatched white highlights on toned paper.

▶ **Brown conte pencil** Delicate gradations of hatching worked up on the female figure in brown conte pencil.

CONTE PENCIL

A soft versatile pencil that is ideal for using on its own or as an underlay to preliminary drawing. Commonly used to add soft tones to figure drawing, it brings a warmer feel to the work than graphite and charcoal. A conte pencil can be hatched and cross hatched in the same way as a graphite pencil.

◄ COLOR PENCILS

There are many varieties of color pencil available and they are used in a similar way to graphite pencil, to build up areas of tone with hatching and cross hatching (see page 114). Blends of color can be worked over one another to create subtle or vibrant effects by applying light or firm pressure to the pencil.

► **Water soluble color pencils** Good quality water soluble varieties are now widely available. By simply adding a little water with a watercolor brush, the effects of watercolor wash can be introduced to your drawing, as you can see in the example on the right.

◄ CHALK PASTELS

Chalk pastels are available in a vast variety of colors and tints and are graded by their softness. The softest pastels are quite crumbly and messy to work with, but don't be put off as they produce a wonderfully luxuriant and velvety finish. You can work with the edge of the pastel stick for fine lines or with the side for soft veils of color.

▼ **Soft pastels** These are ideally worked on pastel paper, with a slightly rough surface called a "tooth" which picks up the fine pigment dust. Particularly good results can be achieved by setting the pastels off against a toned paper, which gives them a glowing quality. Try experimenting by laying some small swathes of color pastel on a selection of differently toned papers.

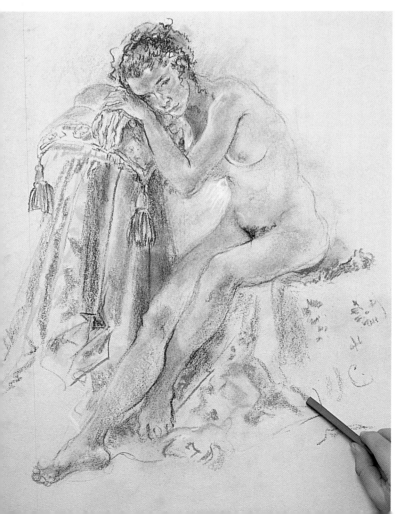

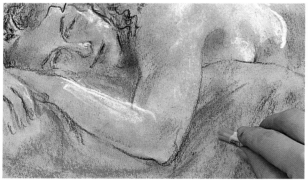

◀ **Compressed pastels** These are hard chalk sticks and fairly brittle. They can be sharpened to a tip to produce a dense and positive line, ideal for making preliminary underdrawings and sharpening definition to chalk pastel work, but can also be used alone for detailed work or on their side to block in broad sweeps of tone.

▶ **Blending and blocking in** Chalk pastels are so soft that they can easily be blended together on the paper using a finger or a rag to produce striking color combinations and are ideal for blocking in large areas.

▼ **Fixative** Chalk pastel work is very vulnerable to smudging. You can "fix" a pastel drawing to the paper with an aerosol fixative or use a diffuser with a bottle of liquid fixative. Working in a well ventilated area, spray the finished drawing evenly from a distance of approximately 4 in (10 cm). Too much fixative can have a dulling effect on the work, so many professional artists choose to fix very lightly (or not at all) and interleave their chalk pastels with acid free tissue paper (available in art stores) for protection.

▶ OIL PASTELS

Oil pastels can be bought in a wide variety of colors and grades of softness. The softest varieties have an almost creamy consistency and can be blended on the paper to give particularly rich glowing colors.

Use harder varieties of pastels or simply apply less pressure on the stick to produce delicate layers of soft tone. This works very well on a toned pastel paper with a slight "tooth" allowing the texture and color of the paper to show through the pastel work.

◀ **Sketching the outline** Mistakes in oil pastel cannot easily be removed. You might find it useful to make a light preliminary sketch in carbon pencil to provide a guide first before adding the pastel.

▶ TECHNICAL PEN

This delivers ink to the paper through a narrow metal tube, producing an even line of a specified width that is unaffected by hand pressure. It is ideal for detailed linework and can be used to draw in delicate hatching and cross hatching lines, suggesting shadow and subtle textural variations.

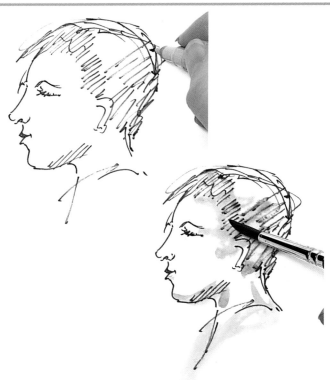

▶ **Water soluble technical pen** These come in a range of thicknesses and can be used to make fast, lively line work or focus on sharp definition. By adding water with a brush, they can easily be worked into delicate tonal-wash sketches, perfect for drawing on the spot and working up later.

▼ INK WORK

Colored inks can be applied with a brush or a nib. Waterproof inks are denser than the non-waterproof varieties, are capable of very precise work, and dry to a slightly glossy finish. Non-waterproof inks dissolve if washed over with water and dry to a matte finish.

▲ **Dip pens** There are many nibs available to produce a wide variety of marks. Shapes and sizes vary, so test out a few until you find one that is comfortable to use. Several different nibs may be used during the course of a single work. Fine nibs will give a very thin fine line ideal for intricate detail and hatching areas of delicate tone, while a broader nib can bring vigorous expressiveness to line work. You will need a pen holder that fits your hand, and a small selection of nibs to experiment with.

▼ **Ink and brush** Inks can be applied with watercolor brushes to produce the same effect as watercolor, diluted with water to add washes of tone or worked "wet on wet" to allow the colors to bleed into one another.

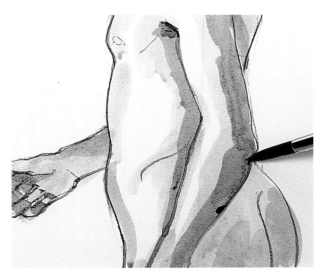

▲ **Fine nibs** A fine nib is used to hatch the areas of tone. This style is appropriate to the subject matter, a serene seated nude.

◀ **Mixed media** Many permanent drawing inks can be combined with other media, as once they are dry they are permanent and won't bleed. The artist makes a drawing with ink, and when it is dry, adds layers of acrylic wash to bring in semitransparent color tones.

WATERCOLOR

Watercolors can be bought in tablets (also known as pans) or tubes in a large range of colors and tints. The paint is mixed with water and can be diluted to varying degrees of transparency. Its most outstanding quality lies in its purity and freshness. Watercolor is frequently used on brilliant white watercolor paper (see illustration), allowing the brightness of the paper to shine through the "glazes," so the brightest highlights in watercolor work are found on the untouched areas of the paper.

▼ **Watercolor paper** This is woven, acid-free, and usually white. It comes in degrees of thickness and in three different textures: rough, cold-pressed, and hot-pressed. Rough paper has a pitted surface that is perfect when you want a broken texture. Cold-pressed watercolor paper has a slightly rough surface; it is widely considered to be the most versatile and easy to use. Hot-pressed paper has a very smooth surface and is good for fine detail.

▲ **Wet on wet** Stunning blends of color can be made by working wet on wet, allowing them to "bleed" into one another on the paper. This creates soft edges and a variety of exciting effects. Painting wet on wet over a large area involves a lot of water, so you must stretch the paper first (see pages 124–125).

▲ **Wet on dry** The artist allows the picture to dry between each new layer of wash, in this way intricate details can be well defined.

▼ **Gradations of wash** The color strength is determined by the amount of water added to dilute the pigment.

▼ **Scratching out highlights** Fine white lines can be created by scratching color away with a blade to reveal the white paper beneath. Let the painted surface dry completely, then use the point of the knife to scratch into it. This is a useful technique for creating highlights.

▲ **Masking** Brush masking fluid onto the paper on the areas you wish to preserve. Once the masking fluid is dry, it can be freely painted over as it acts as a block to the paint. When the paint has dried, the masking can be removed by gently rubbing with a finger.

◄ **Masking wax** Wax resist, which can be candlewax, oil pastel, or wax crayon, also blocks paint, but less completely than masking fluid, so it can be used to produce interesting effects.

◄ PAPER

Although it is easy to get excited about the enticing range of drawing materials available, it is important to consider the ground on which these will be applied. Again, the variety of commercially available papers is almost endless, and although drawn masterpieces have been worked on the most fragile grounds, to get the most out of your work—and preserve it for the future—the ground is a very important consideration. Some papers come in beautiful colors and textural surfaces, but can be expensive and not necessarily appropriate for your work; a good art store might have a small sample book of papers which will allow you to try out a range before you buy. It is certainly wise to buy one or two sheets at a time rather than committing yourself to a pad of paper you

haven't used before. Many artists find just two or three papers to suit the media they use, get to know the paper and then stick to it for consistent results.

As a general guide, regular drawing paper is well suited to drawing in charcoal and pencil, but a heavier weight will take light washes. Ingres paper is used widely for chalk and oil pastel work as it has a fine tooth and comes in a variety of tones. Watercolor papers can be bought in varying weights from heavy to light. The heaviest will allow for reworking and several layers of washes while the lightest are ideal for watercolor sketching. Before adding any wet medium to the paper, it should be pre-stretched to prevent buckling. A pad of medium weight watercolor paper is a good starting point for wet media. These can be bought pre-stretched, allowing you to work directly onto them; or you can stretch the paper yourself by following the simple procedure below.

Stretching paper Many papers will swell and buckle when wet. This obviously creates problems if you are using wet media such as watercolor. Stretch the paper before you start work to avoid ruining your work and wasting a lot of time.

You will need:
Clean drawing board
Gum strip
Clean rag or sponge
Tray of clean water

► **1.** Make sure your paper fits on your drawing board with a wide margin on each side. Tear off four lengths of gum strip, one for each paper edge, making each length longer than the paper.

◄ **2.** Put these aside while you pick up the paper at two corners. Immerse the paper in the water until saturated, then lift out, letting any excess drip back into the tray.

124

media and technique directory

▶ **3.** Lay the paper flat on your drawing board ensuring that you leave a wide margin of board exposed. Moisten the gum strip and attach it to all sides of the paper where it meets the board.

◀ **4.** Very gently wipe over the surface of the paper to smooth out any ripples and remove any excess moisture. When the paper has fully dried it is ready to use on the board or can be cut carefully away from the board with a mat knife.

MAKING A VIEWFINDER

You can make a simple viewfinder using some cardboard (a cereal box is ideal), a pencil, a ruler, and a pair of scissors.

▶ **1.** Place the cardboard on a clean, smooth surface. Use a pencil and ruler to draw a frame around the sides of the cardboard.

▼ **3.** Place the two L-shaped strips over the image you wish to draw as shown, moving one or both of them outward or inward to decide the crop of your final image.

▲ **2.** Cut the cardboard along the pencil lines to create two L-shaped strips.

Index

Credits

key: t = top, b = bottom, l = left, r = right, c = center

Glynis Barnes-Mellish 6 c, 98–101, 122 br, Julia Cassells 6 l, 106, 112–113, Cloe Cloherty 4, 8r, 28 r, 53 br; 62–63, 64 tl, 67, 69 tr, 80–81, 116 br, 119 b, David Cottingham 2, 7 l, 23 br, 29 br, 39 tl, 66 l, 74 b, 76 br, 77, 78–79, 82, 86–89, 122 tl , 125 b (www.cottingham-art.co.uk), Stephen Crowther 38 tr; 53 cr, 121 br, 114 br, 115 cr, 121 br, Terence Dalley (fid.dal@virgin.net) 39 cr, 46 r, 52 t, 60–61, 68 cr; 102–105, 123 tl, Doug Dawson 31 cr, Barry Freeman 31 bl, 58–59, 120 tl and tr, Ruth Geldard 24–25, 38 b, 90–93, 121 bl, Isabel Hutchison 11 bl, 13 tr, 15 tl and br; 19 bl, 23 bl, 28 tl, 30 bl, 34–37, 41 bl, 52 cr, 119 tr, Maureen Jordan 1, 9, 55 t, 65 tr, 69 tl, 118 br, Clarissa Koch 3, 47 tl, 50–51, 52 cl, 68 bc, 115 bl, 117 cl, Hazel Lale 64 b, Andrew Macara 65 cl Lorna Marsh 8 l, 11 br; 38 tl, 52 bc, 53 l, 55 bl, 64 r, 117 br, 118 bl and br, Gary Michael 65 br, Ray Mutimer 5, 7 r, 107, 110, Elinor Stewart 29 bl, 70–71, 111 t, 116 tl, Neil Suckling 21, 47 r, 54 bl, 75 b, Mark Topham 29 t, 56–57, 83 r, 108–109, 111 b, Lucy Watson 11 tr, 14 br; 17, 18 b, 22 bl, 23 t, 26, 27 l, 31 t, 32–33; 39 bl, 40, 41 br, 42–45, 44–45, 72–73, 75 tl and tr, 76 t, 94–97, 114 bl and c, 120 b, Simon Whittle 48–49

With special thanks to Briony Chaplin of the Mall Galleries, and David Cottingham, Simon Whittle and all the members of the Hesketh Hubbard Art Society who have contributed so generously to this project.

All other photographs and illustrations are the copyright of Quarto Publishing plc. While every effort has been made to credit contributors, we would like to apologize in advance if there have been any omissions or errors.